Growing

Up

Growing Up

A Gardener's Guide
to Climbing Plants
for the Pacific Northwest

Christine Allen

Illustrated by Michael Kluckner

STELLER
press limited

PUBLISHED BY

Steller Press Limited
1 - 4335 West 10th Ave.
Vancouver,
British Columbia
V6R 2H6

illustrations and design by Michael Kluckner

Printed in Canada

CANADIAN CATALOGUING IN PUBLICATION DATA

Allen, Christine
 Growing Up: A gardener's guide to climbing plants for the pacific northwest

Includes index
ISBN 1-894143-06-X

1. Ornamental climbing plants – Northwest, Pacific II. Kluckner, Michael
II. Title

SB427. A44 2001 635.9'74' 09795 C2001-900528-8

For Margaret Martin

who led me down many garden paths

 # Growing Up

A gardener's guide to climbing plants for the Pacific Northwest

Table of Contents

II. Climbers for Special Purposes 119

IPOMOEA (MORNING GLORY)

 Introduction

ardeners are never satisfied. Part of every year's ritual involves the regular stroll among the beds with a critical eye, noting a need for contrast here, an unexpected gap there, an area suddenly bleak in a particular season. In established gardens, there is also the search for opportunities to wedge in another plant among the host of favourites already in place.

Climbing plants are admirably suited to solve these sorts of dilemmas, especially as most of them occupy little space at ground level. A garden is by definition an enclosed space, an outdoor room. And most gardens, like rooms, have their edges defined by vertical barriers—by "walls." Just as inside the house we select the colour of paint for our walls and the pictures and hangings with which we adorn them, so outside we have the pleasure of adorning our garden walls, and a wide array of plant "draperies" from which to choose. Within these boundaries, structures that define different areas provide more surfaces to decorate with interesting colours and textures. Trellises, arches,

pergolas, gazebos, tripods, pillars and posts, not to mention the walls of the house itself, add another dimension to the garden and many are, of course, installed for the very purpose of supporting a decorative vine.

Sometimes, there are practical as well as aesthetic reasons to create a garden structure. Unless your garden is very small or you have opted for a classic knot garden, you are going to want to break up the sight lines somewhere, whether to block out an ugly telephone pole, frame a magnificent view or simply add an air of mystery by not revealing all of your garden at once. Perhaps there is already an element of height in the form of a tree or large shrub, but you sense that it needs a little jewellery to hide a flaw or emphasize a characteristic at a certain season of the year.

Admittedly some of these vertical elements are beautiful enough to stand unadorned. Cluttering a fine specimen of a tree with a vigorous clematis, for example, is for my taste rather too much like festooning a chandelier with cobwebs. But a wisely chosen climber enhances even the most attractive structure. Some barriers, like chainlink fences, cry out for decoration; others—pergolas for instance—are expressly designed to be hung with living tapestries. In these cases the issue is not whether to adorn them but how to choose the right plant. Do you want an evergreen curtain or ever-changing entertainment? Is it to have brilliant fall foliage? Fruits for decoration or food? Fabulous colour in summer or stunning structure in winter? Are flowers the most important

consideration? Or fragrance? And in which season? Should it repel intruders or welcome wildlife? Or both?

My purpose in writing this book is threefold: to show how wide the choice actually is for gardeners in the Pacific Northwest; to provide enough information about the attributes and needs of each plant to make the final selection easier; and, most importantly, to encourage all gardeners to hang at least one more climber on their outdoor "walls."

In narrowing down the choice, the crucial issue is timing. Whether the purpose is to add another player to an orchestra, or to introduce a soloist at a point when the chorus is resting, you want it to happen at just the right moment. For that reason, this book is organised by season, and each description includes details of when flowering or fruit or leaf colour is at its height. Where a vine has more than one season of value, it is listed under the one in which its most impressive display occurs. A separate section offers suggestions for particular purposes, such as year-long interest.

 # The Mechanics of Climbers

Understanding why and how plants climb is part of choosing the right one for your needs. The why is easy: most plants equipped with the means of climbing are woodland plants whose only way to obtain the sun they need for flowers and fruit is to make their way up through a canopy of taller shrubs and trees.

True climbers do this in a number of ways. Anacondas of the plant world like honeysuckles and runner beans lasso the nearest tree trunk or post, and spiral their way upward with a chokehold on their host. They require the sturdiest of supports and some of them, such as wisteria, will overwhelm the crown of a tree if given half a chance, killing it with love. In fact, none of these enthusiastic twiners is a good choice for climbing into trees, either for practical reasons or for aesthetic ones.

Less vigorous climbers have tendrils that curl gently around a thin cane or branch, the best known being members of the pea family, which have coiling elongated leaf-tips. Netting, string or chicken wire are quite strong enough to hold these lightweights. Clematis and climbing nasturtiums use their petioles (leaf stems) as tendrils and like a slightly more substantial host to grasp. Heavy non-flexible wire or the slender stems of a companion plant work best for them.

Most suited to walls or hefty tree trunks are the grippers like ivy and and climbing hydrangea which attach themselves by suction. These have the advantage of not needing additional framework to help them climb and because, once

established, they hold on so securely at very short intervals, they are not likely to be dislodged by winter gales (or for that matter by you if you decide they've become too rampant!). However ivy, like wisteria, makes such a weighty mass when it runs out of support that it can threaten even a large tree.

Members of the rose family elbow their way up a tree by throwing long canes over a branch and hooking onto it with their thorns. They need help to climb a smooth surface like a post which doesn't offer them any horizontal support, but make ideal subjects for weaving through latticework or post-and-wire fences. *Elaeagnus glabra* also belongs in this group, using short, sharply-angled leaf stems like grappling hooks to latch onto handy branches.

Finally, there is a group of plants that aren't technically climbers at all but can be encouraged to do the same job if they are anchored mechanically to a support. These are mostly shrubs with long flexible stems like winter jasmine, or groundcovers that can be pushed over the edge of a wall or windowbox to hang like a valance from above.

Success with any climbing or creeping vine depends on understanding its method of attaching itself and suiting the right kind of support to the idiosyncrasies of the plant. In the theatre of the garden you are the stage manager and director; your role is to choose the right aspect, prepare the soil well and set the stage with the appropriate props. With those details in hand, you can select your cast, sit back and enjoy the performance.

Planting & Tending

Climbing plants developed their unique abilities out of necessity. All plants need light to prosper, and most need sunshine to encourage flower and fruit development. In the wild, climbers are found in woods and forests where their only hope of obtaining their share of these commodities is to scale the surrounding trees and shrubs until they emerge above the canopy. Bearing this in mind makes it easier to choose the most appropriate place for them in the artificial world of the garden. Woodland soil is generally moist and rich with the nutrients from fallen leaves. It is shaded by foliage, either densely or dappled with sunlight filtering in through leaves and branches. Vines are drawn upwards towards more light, flowering best in full sun above the competition. Recreating these conditions will bring you the best rewards, and you have far more means at your disposal than the average forest offers for your climber to use as a support.

Shade for the roots means planting your vine always on the north side of its host, letting it twine or crawl its way around to the sunny side as it grows. Where this is impossible, mulch the soil well or cover the root area with a paver or a slab of rock. A container of complementary plants looks good too.

Water all new plants well and don't let mature ones dry out in long summers. If pruning is necessary, the where and when is given in the description, but the general rule of thumb is to do it immediately after flowering on once-blooming plants, or in the dormant season on those that repeat bloom. If a vine is evergreen, winter or early spring is the best time. In most cases, if you prune at the wrong time, the worst that will happen is a season without flowers. Grapevines are an exception because of the way they bleed sap in the growing season.

If possible, always leave an apparently dead perennial vine undisturbed for at least a year. Many, especially clematis that are prone to wilt, will sprout again after a period of convalescence.

A number of climbers will cope quite well with less than ideal conditions and a few will even thrive in dry exposed sites. Nasturtiums, for example, won't do well in shade and respond to rich soil with more leaves than flowers. Consult the section on *Tough Climbers* for some more recommendations.

 # A Note on Nomenclature

Vines are listed by their botanical names with common names following in brackets. There are a number of reasons for this:

• many plants have no common name, especially ones that are fairly recent introductions from countries like Asia where new species are still being discovered;

• a number of plants have more than one common name, making it difficult to decide which they should be listed under. Each has, however, a unique botanical name consisting of a family name or "surname" and a species name equivalent to our first or given name;

• there are a number of climbers that belong to the same botanical family, but have common names that give no inkling of this relationship. As they are obviously going to have similar characteristics, it makes sense to group them together under their shared botanical "surname";

• like many gardeners who have educated themselves by reading books and catalogues and attending lectures by botanical experts, I have become more familiar with botanical names than common ones. If you are a serious gardener, you too are comfortable with their use, or on the way to becoming so.

For those who still feel uneasy in the presence of Latin, an index of common names is included, and within the individual descriptions I have used common names or both names to make the information more accessible. The *RHS Plant Finder 2000-2001*, compiled by the Royal Horticultural Society, is my final arbiter on all names and spellings.

CLEMATIS ARMANDII

Spring

In other ways such an optimistic time of the year, spring is perhaps the most disappointing time of the year for climbers. While the rest of the garden bursts into bloom, few climbers open their flowers this early in the season. There's a certain pleasure to be had from seeing fresh green leaves unfolding on many of winter's bare stems, but it hardly compares with the enjoyment we get from the flowers of snowdrops and daffodils, or the cheery little faces of hardy primroses. By May, of course, many of the early clematis are in bloom, but only *Clematis armandii* will brave fierce March weather without flinching. Still, although the choice is smaller than in other seasons, there are some spring beauties well worth considering, and if not all of them have dramatic flowers, they make up for it in the brightness or shapeliness of their foliage, often serving as excellent companions for the stars that occupy the front of the stage.

Clematis

(See also Summer and Autumn Clematis)

Truly called "the queen of vines," clematis can be found blooming in every season of the year and in almost every colour of the rainbow. They range in size from modest shrubs which don't climb at all to giant sprawlers, climbing by means of flexible leaf stalks which twine around any suitable support they encounter and capable of cloaking a tall tree. There are evergreen and deciduous varieties, small vines and enormous ones. Some flowers are large and flat, the size of a spread hand while others are tiny bells of thumbnail size. The colour range is as wide as the spectrum and the season of flower may be spring, summer or fall, with some varieties blooming twice a year. Almost all have beautiful, silky seedheads as dramatic in their way as the flowers.

 Young clematis usually come in a pot with a stake stapled to the side, which has to be carefully unfastened before they can be removed. Soak the roots well by standing the pot in water for 10 to 15 minutes, and be careful not to damage the brittle stems as you tip them out. Plant the vine, including its stake, several inches deeper than it was in the pot and gently lean the stake towards the permanent support that you want the tendrils to grip.

Despite their differences, all clematis like the same growing conditions—feet in the shade, head in the sun—although some of the most vigorous varieties are perfectly happy in considerable shade, and those with particularly vivid flowers fade in strong sunlight. Choose the spot carefully in advance as they resent disturbance once they are established. Where there is a choice it is always best to plant them on the north side of the structure they are going to climb and let them make their own

way around to the sunny side. If this is not possible, protect the roots by covering them in some way, either with a large rock or paver, or with a thick mulch, or even the spreading foliage of a low-growing shrub. If you plan to mingle them with another plant, be sure to give each enough space for their roots. Young plants cannot compete with the root system of established trees and should either be planted outside the tree canopy and trained along the ground and up the trunk, or given a much larger planting hole closer to the trunk and trained up a temporary support like a bamboo pole into the lowest branches. In the latter case, it is wise to install some kind of barrier underground to prevent the tree roots from growing back into the rich soil you are providing for your treasured vine. This could be a large cardboard box or fibre pot with the bottom cut out. I find a length of flexible metal chimney-flashing ideal for lining the sides of a planting hole.

On the other hand, a smaller host plant may find itself threatened by the clematis. Over time, clematis develop a root system like a huge ball of yarn—fine for them, but not for the unlucky shrub competing for some of the same space. I use the distance between my fist and my elbow as a convenient measure of the space to allow between centres. It is not a perfect guide, but it is always at hand, so to speak. Give them this much distance from a wall too, especially under the eaves of a house, so that they are not parched by the dry soil at the base.

The soil should never be allowed to dry out or conversely become waterlogged, either of which can lead to disease, especially the dreaded clematis wilt, a fungus that attacks virtually overnight and kills all stems above ground level. Susceptibility to this problem is the main reason that clematis, unlike other plants, should always be planted deeply, setting the roots up to 6 in (1.8 cm) below the surface of the soil. This ensures that, in the event of it suffering from wilt and dying off above ground, there are enough healthy shoots below ground to rejuvenate the plant. Planting deeply also gives additional protection to the brittle stems, as wounds

in these are where the fungus enters.

Clematis like a rich, alkaline soil and will appreciate an application of rotted manure or compost mixed with a handful of dolomite lime in fall. In early spring, a scattering of sulphate of potash around the roots will stimulate growth and encourage good flower colour.

The vines climb by wrapping their leaf stems tightly around a slender support. This makes them ideal subjects for chain link fences, but means they will need some help to cover a wall or scale a solid post or tree trunk. Wire mesh or thin wires strung horizontally work best. Lattice slats are too wide for the tendrils to grip. Don't worry if the wire looks unsightly at first: a healthy clematis will soon cover it with its own network of stems.

As pruning depends very much on the variety, you will find those details under the relevant entry.

O f all the vast clematis family, those that bloom in spring are the easiest to prune—because you don't. If pruning becomes necessary, whether to control their sprawling growth, to prevent the smothering of a host shrub, or simply because you are the kind of person who is offended by unruly, bad-hair-day growth, tackle this as soon as possible after flowering, usually about the end of May. This gives them the whole growing season ahead to establish a new framework to carry next year's flowers. Pruning at any other time means you are risking a barren year to come.

Clematis armandii

One of the earliest of this large family to flower, *Clematis armandii* makes a spectacular show that begins in mid-March and carries on into April.

When its masses of small, starry flowers open on slender stems, cascading over the foliage, and the sweet scent wafts through the air, you know it's spring. 'Snowdrift' is the most common variety, but it is worth seeking out the pale pink 'Apple Blossom', which is equally spectacular and just as scented.

Being evergreen, this early-blooming clematis has some merit at any time of the year, and is both vigorous and dense enough to be a good choice for covering an unattractive surface. The overlapping layers of long-fingered leaves create an interesting three-dimensional effect and are a pleasant dark, matte green. Occasionally they will brown at the tips, which is usually due to wind damage, especially in winter, or a lack of potash.

It is important to choose a suitable framework for its twining leaf stems to clutch. I made the mistake of offering it a wooden trellis—much prettier than wire, but the slats were too wide for the clematis to attach itself to and the experiment almost failed. Wire is best because it is easy for the leaf stems to grasp. Choose a heavy fencing wire like page wire or field-and-farm, which is thin enough for the leaf stems to twine easily around but strong enough to hold up the considerable weight of a mature vine. This framework may not look pretty in the early days but the vine will quickly disguise it. I would not opt for anything as thin as chicken wire as eventually the vine will pull it away from the wall.

It is also important to site this vine on the north side of the structure you want it to adorn. Let it make its own way around to the sunny side, or encourage young stems in that direction. In an exposed site, the woody trunk will remain bare until its arms find a more accommodating location for its flowers and foliage. If you want to train your vine in a certain direction, gently coax young stems that way. Mature ones resent any interference and will demonstrate this by dying if pushed around.

Clematis armandii is an easy-care vine, needing no pruning except to remove dead stems or to confine it to a certain area. If this is necessary, then after flowering is the best time but I have pruned my specimen whenever it began to obscure the door it overhangs and it has not punished me for this. The leaves can suffer from scorching in winter so a protected position facing east or west is desirable. I know this from experience, having planted mine on the partly shaded southern side of a shed from which it has ever since tried to escape. It now forms a curtain on the east and west walls, with only a bare trunk facing south.

Like all clematis, it will welcome an annual application of lime and a good mulch of well-rotted compost that will not only feed it but help to keep the root-run cool in summer. Although seed of this species is sometimes available, it generally produces an inferior plant.

Clematis alpina

The delicate nodding bells of the alpine clematis decorate the April and May garden. Small in size, like most alpine plants, they rarely achieve more than 6 ft (1.8 m) and effectively fill the gap between spring groundcovers like saxifrage and the taller shrubs such as viburnums which also flower at this time. Of all the clematis, these are the ones that flourish best in full sun, but like other members of the group they prefer a cool, but not sodden, root-run. One of the best ways to achieve this is by covering the base with a shallow birdbath or a pot of low-growing plants in complementary colours over which the clematis flowers can hang.

Blue, white or pink forms are available. The species itself produces narrow trumpets of rich blue with white stamens, while 'Frances Rivis' has larger flowers in a deeper blue, 'Helsingborg' has longer narrower tepals (the petal-like bracts) in dark violet with matching stamens and 'Ruby' is a rather muddy pink. All grow to between 6 and 8 ft (1.8 to 2.4 m) and flower early on last year's growth, often with a few additional flowers in late summer. Pruning is not usually necessary but can be done after flowering if a mat of old stems is preventing new ones from emerging.

Clematis macropetala

Sometimes called Downy Clematis because of the fine, soft hairs on young leaves, this is a more vigorous clematis than Clematis alpina, but a still manageable climber to 12 ft (3.5 m) or so.

Where *C. alpina* has single flowers, usually with four tepals, *C. macropetala* has double that number or more, which gives it a more showy appearance. In April and May it bears frilly flowers with an ring of fanned tepals around a paler inner set like a ballet dancer's skirts.

In the original species the colour is violet-blue, and the majority of garden forms, many of which are hybrids between *C. alpina* and *C. macropetala*, are paler or darker variations of this colour. However, there are also some attractive pink and creamy-white forms, some of the best being hybrids developed in Canada.

'Blue Bird' is a softer colour than its parent while 'Maidwell Hall' is a deeper, richer blue. 'White Swan' is a reliable white, and 'Rosie O'Grady', bred in Manitoba by F.L. Skinner (who was also responsible for the honeysuckle 'Dropmore Scarlet'), is one of the prettiest pinks, although 'Markham's Pink' is also popular and certainly easier to find. 'Georg' has rather small, indigo flowers but flowers over a longer period than most—well into summer.

On both *C. alpina* and *C. macropetala* large silky seedheads follow the flowers to provide a second season of interest.

Clematis montana

The giants of the spring-flowering clematis, all the montanas require a sturdy support and a lot of space. Excellent for covering a sizeable shed or fence, they will thrive even on the north side. If they do produce fewer flowers in this aspect, you would be hard-pressed to notice, so generous is the amount of bloom. Masses of small, starry flowers cover the vines so thickly in early May that they form a curtain of colour and waft their strong vanilla scent across the garden.

Clematis montana is often recommended for growing into trees, but its mature size—15 to 40 ft (5 to 12 m)—means that it will overwhelm all but the tallest tree, and even then its weight may bring the tree down in a strong wind. Besides, beautiful as the effect is during flower, for the rest of the year you have something that looks like a monstrous cobweb obscuring the elegant shape of your cedar or fir.

Among the easiest and most trouble-free clematis, it requires no pruning other than to keep it within bounds. It occasionally succumbs to clematis wilt (see above) but if pruned to the ground, it often recovers, sometimes long after you have given it up for dead. I have a plant in my garden that used to be struck by wilt every year, just as it broke into bud. Thinking that I had nothing to lose by moving it, I dug under one half of the root ball and then, distracted by other tasks, never got around to finishing the job. The following year and every year since, it has grown and bloomed without a hint of disease.

The most popular varieties are *C. montana var. rubens* and its forms, all of which have plum-coloured stems and plum-flushed foliage. The parent plant has pale pink flowers, 'Tetrarose' is similar but with larger flowers, 'Elizabeth' is a paler pink with a strong fragrance, and 'Broughton Star' has double flowers of a warmer rose-pink. 'Marjorie', another pink, has semi-double flowers.

Among the varieties with crisp green foliage, *C. montana grandiflora* is white, as is *C. montana var. wilsonii* which blooms later than the others, in June-July.

Late Spring Hybrids

These are the clematis with huge flat flowers that make such a dazzling display when they all open at once in mid-May. Easy-going plants, they will reach 8 to 12 ft (2.4 to 3.6 m) and thrive in any aspect provided that they are well-fed and well-watered. They bloom on the ripened stems of the previous year, and need no pruning other than the trimming of winter-killed tips. However, young plants will produce stronger shoots lower down if you can steel yourself to cut them back to about 8 in (20 cm) from the ground after planting.

Flowers will last for about four to five weeks and you will get a second but

less prolific show in September. The vines are at their most impressive when displayed alone against a fence or wall, but one of the most beautiful combinations I have seen was a 'Nelly Moser' trained as a garland up the bare trunk of an old, meticulously-pruned willow. With its candy-pink stripes down the centre of each pale pink tepal, 'Nelly Moser' is by far the best known of these clematis and the one most receptive to a shady location. In full sun the young flowers take on a green tinge and the colours are bleached. 'Bees' Jubilee' is a similar colour and a better choice for full sun.

Among the blues, 'Lasurstern' is blue and lavender, 'H.F. Young' has slightly smaller but more prolific wedgwood flowers and the semi-double 'Beauty of Worcester' has layers of deep blue flowers with white stamens. 'Vyvyan Pennell' is a weak grower but has fabulous ruffled double flowers in soft lilac and violet—if Mae West were a flower, she'd be this one.

Two beautiful whites are the single 'Miss Bateman' with chocolate stamens, and 'Duchess of Edinburgh,' a *Clematis florida* hybrid, whose curious buds open into breathtaking double white blooms, repeating the display in fall with equally lovely single flowers.

'Countess of Lovelace' is another *C. florida* hybrid with double flowers of soft periwinkle blue followed later by singles.

For all these large-flowered hybrids, most of them belonging to the patens group, use the planting instructions for **Spring Clematis** above.

Akebia quinata (Chocolate Vine)

Supposedly, this twining climber gained its common name from the scent of its small, plum-coloured flowers. If so it's a somewhat optimistic evaluation—the term "elusive" springs to mind. However, Akebia is a visual pleasure for the garden,

with attractive leaves of fresh green almost year round, and the dangling clusters of flowers, although hardly spectacular, are pretty when they sprinkle the neat foliage in late April and May.

Although often slow to get going, this is a plant that requires some vigilance once established to keep its enthusiasm in check, as the stems will fondly reach out and strangle any nearby shrub. For these reasons, it is as well to choose a sturdy, non-living support like a pergola. In Vancouver's VanDusen Botanical Garden, for example, it makes a superb cloak for a latticed arbour and shelters a comfortable bench from sun or showers. The trails of five-leaflet leaves, splayed like the print of a cat's foot and increasing from dime- to saucer-size as they descend from questing tip to mature woody stem, give an overall sculptural effect to the hanging curtain that eventually develops.

It is happy in sun or shade, disease-free, and will perform well in all soils. It needs no pruning, but if you do the flexible stems make excellent bases for wreaths. Occasionally, if there is cross-pollination, interesting edible pods like purple sausages will form in autumn. There is a white form, *A. quinata alba*, athough it's difficult to find.

In a mild winter, *Akebia* will remain evergreen, although the leaves are inclined to wilt in cold weather. It is equally happy in sun or part shade, and vigorous to the point of becoming invasive, as trailing stems will root where they touch the ground. Its ability to smother whatever lies in its path is a virtue if you are trying to hide an eyesore like a chainlink fence, but can be a vice if the obstacle is a treasured shrub. I used it as a windbreak to protect a tender China rose, until it threatened to throttle the rose and it had to go. It didn't go easily either.

WISTERIA

Wisteria

The star performer of the May garden, so well known that it doesn't need a common name, wisteria is nonetheless a puzzling and sometimes frustrating plant with which to deal. If possible, always buy a vine in bloom, as this eliminates one source of difficulty right away. For a start, you can rest assured that your plant *will* flower, and secondly, you know what kind of flower you are going to get—how large the clusters are and how deep the colour.

Wisteria are notoriously slow to flower, often taking four or five years to do so, and in some cases will take twice that long, flower poorly, or perhaps not flower at all. This is particularly the case with plants grown from seed, so if you are purchasing out of season, at least try to ensure that you are getting a grafted plant by looking for signs of the join just above soil level. They are temperamental plants to propagate by any method, which explains the high price of good specimens in garden centres.

The two main types of wisteria have decidedly different characteristics which you should bear in mind. Chinese wisteria *(Wisteria sinensis)* is the one most commonly seen in local gardens. It owes its impact to the way its flowers open before the leaves unfurl, and they open all at the same time so that each drooping cluster is evenly filled from top to bottom with fragrant lavender or white flowers. For a curtain of colour, this species has the edge over its cousin the Japanese wisteria *(Wisteria floribunda)* whose smaller, more-widely spaced flowers open gradually, starting at the base of the raceme and unfolding in succession towards the tip. However, its measured opening of buds means that Japanese wisteria has a longer blooming period, and as the racemes are usually two or three times the length of those on a Chinese wisteria, it has a more graceful look, particularly if drooping

from a pergola. Leaves unfold as flowering begins, which may please you more or less, depending on how intense you like your colour schemes to be, and while both varieties are fragrant, the Japanese has the stronger scent.

Two rarer varieties are *Wisteria venusta*, a fragrant white wisteria with short, chunky flower clusters and silvery leaves, and *Wisteria* x *formosa*, a hybrid of mixed Chinese and Japanese origin, with strongly-scented, violet flowers all opening at once.

If you have inherited a mature vine with your garden and want to determine which type you have, wisteria of Chinese origin spirals anti-clockwise, while the Japanese group go clockwise when viewed from above. The latter also have more leaflets to each leaf—more than 11 compared to fewer than 9 on the Chinese forms.

Many of the wisterias have recently undergone name changes, but nurseries don't always adopt these, especially where customers have become used to the old name. To cover all bases, I've given old and new names below, hoping it clarifies rather than confuses the issue.

Soft lavender is the colour most commonly associated with wisteria, but there are also white varieties, while *W. floribunda* 'Black Dragon' (now called *Wisteria* x *formosa* 'Yae-kokuryu') has particularly dark grape-purple blooms. For the longest, most graceful flowers, *W. floribunda* 'Macrobotrys' (recently renamed 'Multijuga') will produce 3-foot long chains of soft lavender blue, while *W. floribunda* 'Alba' (also known as 'Longissima Alba', 'Shiro-naga', 'Shiro-noda' and 'Snow Showers') is almost as spectacular in fragrant white. There is a double-flowered form called *W. floribunda* 'Violacea Plena', which is less spectacular than you might think as the flowers are prone to damage in wet weather and the racemes are shorter than other varieties.

Although spring is their time to shine, all wisteria have attractive frond-like foliage which provides dappled shade through the summer months and turns a

pleasant muted yellow in fall. In winter, dangling seed pods with their coating of silver hairs are dramatic against rainwashed skies and the dark grey, boa-constrictor trunks of mature specimens contribute structural interest to the garden, particularly against a pale background. Chinese wisteria will often produce a sprinkling of later flowers.

Wisteria need full sun to encourage maximum flowering, and very sturdy supports for their twining stems, which can become as thick as tree trunks over time and extend to 20 ft (6 m). Most of the bloom occurs on the south side, so don't choose the south side of your garden unless you want to give your neighbours most of the benefit. Bearing in mind that their growth is rampant and their roots are vigorous, shrewd gardeners will select a location well away from house foundations. On our old one-and a-half-storey Vancouver house, the Chinese wisteria planted long before our time had no trouble reaching and threatening to tear off the shingles at the peak of the roof. Meanwhile, what it was doing to the perimeter drain tile was evident by the way the porch sagged at that corner. A hefty pergola is a much better option, especially as it allows you to walk under the hanging clusters of flowers, and for true romantics nothing beats the classic look of a row of elegant white columns draped with amethyst flowers.

If you want to cover a broad space such as a wall, train young stems horizontally right from the start. Left to its own devices, wisteria will shoot skyward, leaving bare trunks at eye level and only flowering well once it runs out of support and stems begin to hang down.

To keep the growth manageable, restrict vines to two or three main stems, and prune twice a year, cutting side shoots back to five buds at the end of August and re-cutting back to two nodes in late February.

Aristolochia macrophylla (Dutchman's Pipe)

(formerly *Aristolochia durior*)

Here's a plant to grow for curiosity value. Although it twines to 30 ft (10 m) in favourable conditions, producing a dense blanket of large, felted, heart-shaped leaves, its flowers are small, tucked behind the foliage, and unpleasantly scented. However, they are unusual and quite charming in a weird way, looking like little vegetable saxophones in shades of green and cream with brown marbling on the inside of the trumpets. The foliage has the virtue of lying quite flat against a surface, taking up very little room. The flowers appear in late May, and the leaves change to a dull ochre-yellow in fall before they drop.

Sometimes slow to establish, the vine takes off rapidly and will soon cover the side of a building or a run of fence. Whether climbing into full sun or considerable shade, it prefers its roots in cool, moist soil. Vines are not susceptible to disease or insect damage.

Manchurian Pipe Vine *(Aristolochia manshuriensis)* is similar but flowers a few weeks earlier. A much less vigorous cousin, *Aristolochia californica*, produces its flowers before the leaves unfold, but it is not reliably hardy this far north except in the warmest areas, and so is not readily available.

Humulus lupulus 'Aureus' (Golden Hop)

For a splash of bright colour, this variety of the common hop is at its best in spring when it leafs out in a lime-infused yellow so sharp you can almost taste it. Completely herbaceous, it sends snaking stems aloft from ground level every year, unfurling leaves not unlike a maple in shape but rougher in texture and an acid lemon in colour. Vines grow rapidly and will easily achieve 12 ft (3.6 m) or more by

summer's end.

As the months pass the colour becomes deeper but duller and eventually develops into a dirty gold that makes you glad you can cut it to the ground for the winter. Late in the year the foliage may also be subject to mildew, another reason to take it down.

In full sun, the leaves will often scorch by midsummer, so it is a good candidate for a partially shaded position or at least one which is protected from the intensity of late-afternoon rays. It won't develop quite the same intensity of colour but I consider this an advantage as chartreuse is rarer and blends better with other hot colours than gold.

Female vines are the ones most usually sold since they carry the interesting pale green flowers like miniature paper pinecones which gradually darken to gold and eventually to a light tan.

Golden hop has the twin advantages of being extremely hardy and fast growing, covering a surface densely in short order, ideal for a situation where you want privacy in summer but an open aspect in winter. The young twining stems are easily trained around any thin support but if you want to avert its tendency to mildew, choose an open structure like a wire fence or lattice screen.

It will thrive in any reasonable soil to the point of becoming aggressive. If you want to curb its tendency to spread by runners both above and just below the soil surface, give it the poorest soil in your garden. Shoots spread underground from the parent plant in the same way that mint does and can be difficult to remove if they spread into surrounding lawn. For this reason it is a good idea to confine it to an area where this will not be a problem. The plain green form, which is the one used in beer-making, is even more rampant and best avoided unless you plan on opening a micro-brewery of your own.

Golden hop combines well with purple foliage but will overwhelm a small

shrub so choose a companion accordingly. It is also quite difficult to remove the old stems at the end of the year as they hold firmly to their support and take a long time to become brittle enough to break off of their own accord.

See also *Humulus japonicus*, or Japanese Hop, for summer interest.

Actinidia kolomikta (Ornamental Kiwi)

For sheer drama this deciduous vine is hard to beat. In April you are admiring the bronze-tinged leaves unfurling into green shields, the size of a small hand. In May they change suddenly, as if dipped halfway into a pot of white paint, with the tips then dipped again into rosy pink. This startling and unusual tricolour effect is the plant's way of drawing pollinators to its tiny cream flowers tucked behind the base of the leaf stalks. The colours continue after flowering until, in autumn, it sheds its leaves quietly without another grand display.

It is the male plants that have the vivid colour and this is what you will find in garden centres. Don't be dismayed if your young plant stays predominantly green as it usually takes a couple of years at least before the variegation develops. Slow to begin with, one vine will gradually cover a considerable amount of space, growing to about 15 ft (4.5 m) vertically. I like it better thickly clothing a fence, with white and pink-flowered plants in front to accent its leaves. Although tolerant of light shade, it colours best in full sun. It climbs by twining tough stems around its host, like a honeysuckle, and is equally happy on a tree, a post or a thin wire.

Any reasonable well-drained soil will suit the ornamental kiwi but choose its position carefully as it hates to be moved, and make sure the support is sturdy. Cats are attracted to the woody stems (it's known as *herbe de chat* in French) and may use them as scratching posts. They also like to roll around on the soil at the base so it is as well not to plant any small treasures in that area if you have felines in the family.

LONICERA (HONEYSUCKLE)

 Summer

Other seasons have their beauty but the arrival of summer, long-awaited after months of damp, grey winter and capricious spring, brings more pleasures than any other. Gardens are at their most luxuriant, fragrant with roses and honeysuckle, brilliant with clematis and perennials. I wait all the rest of the year for the few weeks when the old ramblers on my fences foam over their own foliage in huge drifts of snow-white, crimson and soft pink. Long warm evenings bring out the scent of jasmine and its white petals grow luminous in the dusk.

It is a wonderful time to be surrounded by scented, flowering vines. Strolling in the dappled shade of a pergola, or drowsing on the cushions of an arbour seat, gardeners have a little time for leisure to enjoy the results of this year's planning and planting and to contemplate where yet more plants might be added so that next year it will all be perfect. It is always going to be perfect next year!

Hydrangea anomala ssp. petiolaris
(Climbing hydrangea)

One of the most beautiful climbers for a north wall, this hydrangea looks much like the common lacecap varieties in leaf and flower. It climbs by means of little adhesive aerial roots like centipede feet and, other than a little encouragement to begin with, needs no help to make its way up a vertical surface. It spreads gracefully over a wall, and when the broad, lacy clusters of ivory flowers bloom in early summer, they cast beautiful patterns of light and shadow over the surface behind them. Glossy bright green foliage keeps it attractive when not in bloom and, even stripped of leaves in winter, its peeling cinnamon stems draw graceful abstract patterns against their background.

Climbing hydrangea is notoriously slow to establish but then grows rapidly to a height of about 20 ft (6 m) or more. Encourage a young plant by providing moist, rich soil, watering well in its early years and, if necessary, pinning it against the surface until it begins to adhere on its own. Keep a close eye out for slugs which love to feast on young growth before it becomes woody. Mature plants have a naturally elegant, spreading habit requiring little in the way of training or pruning unless you want to control the eventual height.

Although it makes a decorative addition to a tree trunk, it is too rampant for any but the most sturdy trees. If you have a suitable host, be sure to put your hydrangea on the north side and let it find its own way from there, as this is one climber that hates exposed sites, being a forest dweller in its native Asian habitat.

Hydrangea integrifolia is a similar plant, with buds like tiny golfballs surrounded by a few larger sterile blossoms. Loose clusters of highly polished, emerald leaves with red stems fan out beneath the flowerheads as if carefully arranged by a florist. Even more difficult to get started than its cousin, this vine is

said to need a tree at least 80 years old to induce it to climb. What this really means is that it won't attach itself to a smooth surface. Fortunately, our native firs and red cedars have just the kind of rough bark it prefers but if you are planning to plant it against a wall this could pose a problem.

Schizophragma hydrangeoides (Japanese Hydrangea Vine)

Superficially, there is little difference between this vigorous climber and its close relatives above. However, when the flower clusters bloom, they are fringed by larger, more slender sepals, not unlike those of cream-coloured poinsettias.

Vines begin to flower in June, have the same requirements as climbing hydrangeas for planting and slug protection, and will reach similar heights. Given a rough surface to cling to, the stems will pattern it in a relief of warm brown.

The variety *denticulata* has more sharply toothed leaves and makes nice scribbles on a wall or tree trunk in the winter months. It too needs a rough surface to adhere to. 'Moonlight' is a particularly lovely form, less vigorous than its parent, with leaves washed with a milky sheen.

An evergreen member of the genus is *Pileostegia viburnoides* (p. 105).

Lonicera (Honeysuckle)

Just about everyone knows honeysuckle by sight and it is one of the most popular climbers for two reasons—its long and generous flowering season and its scent. A few very worthy garden varieties have no scent but make up for it by having more brilliant flowers. It is interesting that these are in general the North American natives or their hybrids like *Lonicera* x *brownii* 'Dropmore Scarlet' which was

developed by noted Canadian nurseryman, Frank Skinner, in Dropmore, Manitoba in 1950.

Honeysuckle climb by twining strong stems around any handy object, and are good at prising pipes away from their supporting structures as I found out when a vigorous *L.* x *beckrottii* 'Goldflame' separated the conduit carrying power to our yard light from the pole to which it was attached. It is wise to give them lots of space well away from any such vital conduits and cables. Best too, to confine them to artificial supports like pergolas and fences as they may overwhelm or even choke a weaker shrub or small tree. They will thrive in most soils and most aspects although, with the exceptions noted below, they prefer a partly shaded site. Dry soil and too much sun encourage the two most common pests: aphids and mildew.

To prevent plants from becoming bare around the base, prune a couple of stems back hard in late fall or before buds break in spring. If necessary, all stems can be cut back this way to rejuvenate an ancient vine. Otherwise no pruning is necessary unless the vine is outgrowing its allotted space. In fact, the thick, concealing growth offers excellent habitat for small birds which also feed on the berries that appear in autumn. Hummingbirds are particularly attracted to the long, narrow flowers, as are hawk moths, which in turn provide food for bats.

All honeysuckles have long stems with pairs of leaves at well-spaced intervals. Most of the garden-worthy types bear their clusters of tubular flowers in whorls at the end of shoots, usually in soft shades of yellow, white or pink, and often a combination of all three. A few, notably the North American natives, have fiery

bright but scentless flowers including 'Mandarin', the dazzling orange hybrid developed by the University of British Columbia.

There are both evergreen and deciduous varieties, the evergreen generally represented by members of the Japanese group *(Lonicera japonica),* of which the most common variety is 'Halliana' with very fragrant yellow and white flowers from July to September. Those who like variegated foliage can choose *L. japonica* 'Aureoreticulata' which is patterned in yellow and green, with small white flowers gradually aging to buff-yellow. This variety is particularly susceptible to mildew, however, and should be given a partly shaded position to discourage this problem.

Japanese honeysuckle has become a pest in the U.S. southern states and is now banned in several of them. It is entirely possible that it could escape into the wild in our mild climate as well, so consider carefully the consequences of inviting it into your garden and, if you do so, be sure to prune out the fruits before they ripen. Other honeysuckles also have the potential to become invasive, something for wise gardeners to ponder.

Less well-known choices among evergreen honeysuckles include *Lonicera alseuosmoides* with modest cream and purple flowers in July-August and attractive blue berries in fall. It is on the tender side so give it the protection of a sheltered site. A more vigorous and hardy species is *L. henryi,* which has purplish-crimson flowers in June-July and conspicuous fruits like little blueberries. It can grow quickly to considerable size and makes a good screen. Neither of these two species is fragrant but their foliage and berries make a valuable contribution to the winter garden.

Deciduous honeysuckles produce larger flowers than the evergreen varieties. *Lonicera* x *heckrottii* 'Goldflame' is widely grown for its showy crimson and yellow ribbons of fragrant flowers which continue to bloom over a long period, often from June to the end of September. The *L. periclymenum* group is also popular, my favourite being 'Graham Thomas' whose scented, soft yellow and cream

flowers bloom throughout the summer and are followed by berries as bright as red currants. 'Serotina' has an abundance of heavily scented flowers in shades of purple and pale yellow and also has a long period of bloom from midsummer well into fall. It is sometimes called Late Dutch honeysuckle while 'Belgica', which has pink flowers with a pale yellow throat, is known as Early Dutch honeysuckle and flowers from late spring to midsummer. *Lonicera sulphurea* 'Sweet Sue' is similar to 'Graham Thomas' but more compact.

Lonicera caprifolium, the Italian woodbine, is considered to be the honeysuckle of choice where fragrance is the most important criterion. It flowers early—from late April to May—and follows with red berries in late summer. The species has cream flowers flushed with pink, while the variety 'Anna Fletcher' is pure lemon-yellow.

Etruscan honeysuckle *(Lonicera etrusca)* is an option for gardeners in the mildest zones. This native of the Mediterranean bears fragrant flowers aging from primrose to old gold, picking up reddish tints along the way. There are several good varieties, including 'Donald Waterer' with crimson and cream flowers, 'Michael Rosse', which is palest yellow, and 'Superba', yellow deepening to soft orange with age. All bloom from July to September, produce orange-red berries, and prefer a sunnier position than other varieties. They are reluctant climbers, which is a bonus as you can train them where *you* want them to go, and they are not so vigorous as to overwhelm other plants like the rest of the family. Their biggest disadvantage is the

scarcity of sources in this region.

A cross between the two species above resulted in *Lonicera* x *americana*, whose pink and cream flowers grace a long season from June to November. Similar in growth habit to *L. caprifolium*, it has the decorative flower clusters of *L. etrusca* as well as some of its susceptibility to cold. Strongly scented and generous in bloom, it has become one of the most sought after of the family. Despite the name, it is a European hybrid.

Among the scentless varieties, *Lonicera* x *tellmanniana* is best known. In the U.S., it is sometimes sold as 'Redgold', which accurately describes the vibrant hues of its flowers. Generous in bloom and happiest in shade, it will flower through the early part of summer.

Jasminum officinale (Poet's Jasmine)

The heady scent of jasmine has been a staple of the perfume industry for centuries but for the northwest garden only one member of the family is truly hardy. Poet's jasmine, if not the most fragrant, at least has the most romantic name.

A twining plant, vigorous enough to cover an arch or fill the corner of a fence, it is happy in any reasonable garden soil and will tolerate some shade. The most important consideration is a protected angle where it is safe from desiccating winds and cold air. The modest flowers open from pink buds into small white stars from June through to the end of September and give forth their strongest fragrance in the evening.

The pretty and heavily scented star jasmine *(Trachelospermum jasminoides)* is sometimes available in garden centres, but it is not a true jasmine, and is not hardy outdoors in northern climates. In a conservatory it makes an attractive feature, although the scent can be overpowering in a confined space.

Roses

If you are planning to have climbing roses in your garden, consider whether you want a modern climber or an old-fashioned rambler. Each has its merits and drawbacks.

Modern climbers have the advantage of bearing flowers from June onwards and usually continue to produce flushes of bloom well into fall. They tend to have stiff canes that rapidly become inflexible and need to be trained and tied in to their supports as they develop. Their strong, upright habit makes them best suited to trellises, pillars or walls, where in time they will become almost self-supporting and will even support another, more fragile climber such as one of the smaller clematis. The flowers are generally large and they come in a wide range of colours—everything but blue. Breeding for size, colour and constant bloom has taken precedence over both fragrance and disease-resistance for most of the last century but fortunately, among the huge numbers of roses introduced over the years, the ones with staying power have been the ones with all or most of these attributes. A few of them are described in greater detail below.

Ramblers usually begin to bloom a couple of weeks later than modern climbers, and then produce all their flowers at once in great profusion. A month later, flowering is over until next year but most of these roses yield crops of red or orange hips which give them another period of interest in fall. In fact, several of them will hold their bright berries through into the late winter. Ramblers have more flexible canes than modern roses and lend themselves better to draping a fence or

pergola. Given a tree to climb and a little encouragement, they will fling long canes over the branches and ,using their thorns as grappling hooks, haul themselves upwards like mountain climbers on a rock face. Although there is a limited colour range—white and many different shades of pink from seashell to crimson—nearly all of them are strongly scented and they rarely suffer from the diseases that plague more modern varieties. A few will even put out a scattering of flowers after the main display is over, although this comes at the expense of hips. These cascading, undemanding roses are my passion, and those described in detail below are only a few favourites out of the many that grace my garden with their beauty and fragrance every summer.

All roses benefit from a well-prepared soil at planting time. Dig a decent-sized hole about 20 in (50 cm) wide and deep. Fill it with water. While the water drains, mix the soil from the hole in a wheelbarrow with a little peat moss or compost, a handful of bonemeal and some alfalfa pellets or a weak solution of fish fertilizer. Build a cone of soil in the middle of the hole so that you can spread the roots down and out without letting them curl around at the tips. If they don't fit easily, either widen the hole or trim the ends of the roots. Position the rose in the hole so that the graft (the knot at the base of the stems) is just below the soil surface and fill the hole half way with your soil mix, firming it around the roots with your hands. Water this soil again to settle it around the roots and add the rest of the mix, treading down lightly to firm it around the base of the plant. One of my friends says that he always does a little dance around his newly-planted roses, just to make them and himself happy. The Elizabethans would have called it "treading a measure." Pile some extra soil up around the canes to keep them moist; after a few weeks, you can wash it away, being careful not to snap off any new shoots that may have sprouted.

Most climbing roses and all the ramblers are vigorous enough not to require grafting onto a stronger rootstock and can sometimes be found as own-root plants. In their youth, they are generally much smaller than grafted plants but will catch up within three years. If your rose is growing on its own roots, you will not have the grafting scar as a guideline of how deep to plant so just plant it a little deeper than it was in the pot.

Unfortunately for us in the Pacific Northwest, most of the roses for sale in local garden centres come from big enterprises in California, where they are grafted onto rootstocks which are not the most suitable for our climate. If you can find a nursery which buys from one of the few local sources, you are in luck.

Pruning of roses is always a source of anxiety even for experienced gardeners. The most important thing to remember is that you will not kill a rose by pruning it, no matter what you do. However, you may prevent it from giving you any flowers, and this is particularly true if you approach a climbing rose with the pruning guidelines for bush roses. Climbers should be treated like grapevines. That is, they should be allowed to make a framework of long canes which are only cut back at the tips to remove winter damage or to control their height. The laterals, or side shoots, are where the flowers form, and these are the ones you cut back, leaving three or four leaflets or dormant buds to each stem. Each of these stems will then branch again, giving you the maximum amount of bloom. If your rose is not producing many laterals, it is probably because the canes are growing straight upwards. Bending them, even a little, from the vertical will encourage dormant shoots to emerge, after which you can tie them in again vertically if you want. In general, however, they benefit from being wound around a pillar or splayed at an angle against a trellis, as they produce the greatest number of laterals in these positions. Every two or three years, cut out a couple of old canes right at the base to encourage younger ones to take their place.

Ramblers don't need to be pruned at all, except to clear out dead wood or to reduce the whole plant in size. Normally, they will develop many laterals of their own accord, especially if allowed to grow horizontally along a fence or pergola. Of course, you can encourage more by shortening the laterals as you would for the climbers and the best time to do this is as soon as the blooms have faded. You will lose the autumn rosehips for that year, however. Some people like to prune after the hips have lost their brightness at the end of winter and this is fine too, as long as you cut only the spent spray. Leave the new growth that will usually have already begun below this point.

Repeat-blooming Climbers

Among the repeat-blooming modern climbers, the following are excellent varieties for northwest climate and soil condtions. You will notice that many of them have been around for some decades, as indeed it takes a while to determine just how good a climbing rose is going to be. There also seems to have been a dearth of interesting and healthy climbers in the 1970s and '80s, but the tide is turning with a number of potentially exciting new varieties introduced in the '90s. It will be a while, however, before their performance in the Pacific Northwest can be accurately judged. I have included dates of introduction beside each of the recommendations below, because it gives an indication of how long they have maintained their popularity with gardeners.

• 'Altissimo' (1966) has blood-red single flowers with a coronet of golden stamens at their heart. A spectacular sight in bloom, it prolongs the display from summer to fall. Even people who don't like single flowers love this one despite its lack of fragrance. The growth is rather stiff and angular, so it is best fanned against a high fence. The foliage is dark and healthy and the plant will reach an average of about 10 ft (3 m).

• 'Dortmund' (1955) produces masses of bright red, single flowers with a circle of white around the golden stamens. It is a good rose for brightening a gloomy corner, as it adapts well to dappled shade and is capable of competing with trees for nutrients and moisture. Although individual flowers are small, they bloom in large trusses, and should be deadheaded if you want to encourage continued bloom. Height and width around 8 ft (2.5 m).

• 'Dublin Bay' (1974) is simply the best red climbing rose for the west coast, visually that is. Its habit of producing many arching canes with an average height of about 8 ft (2.5 m) makes it a candidate for fanning against a supporting structure such as a low fence or a fan trellis. The flowers are fire-engine scarlet against brilliant green leaves, a combination that draws the eye from a considerable distance. The season of bloom is continuous and long, but there is little energy left for scent as well.

• Climbing 'Etoile de Hollande' (1931) is not the healthiest of climbers but it is included here because it possesses one of the most scented flowers in this category. This is a strong rose with thick canes, rather sparsely covered in emerald-green foliage. The large flowers are a deep, glowing red, beautifully shaped, with a fragrance that all roses should have, the kind that perfume companies are always trying to reproduce. Height to 12 ft (3.6 m).

• 'Handel' (1965), with its shapely scrolled buds opening into Hybrid Tea-style blooms of ivory edged with deep pink, created something of a sensation when it was introduced. Masses of bloom in spring and late summer with lesser flushes in between. It has drawbacks: stiff, inflexible stems, little scent and a inclination towards black spot, but if you don't mind maintaining a regular spray program, it will certainly provide you with a visual treat. It grows to about 12 ft (3.6 m).

• 'Climbing Iceberg' (1968) is better than its parent shrub, as many climbing forms are with their extra vigour. This is the epitome of white roses and has dominated its colour category since it was introduced. Shapely and scented, the flowers open with a greenish tinge and when fully open display a coronet of golden stamens.

• 'Laura Ford' (*aka* 'King Tut', 1990) is one of few miniature roses with a noticeable scent. Dark forest-green leaves set off the pretty yellow flowers, which will provide a colourful display of small hips if not deadheaded at the end of the season. It has a mature height of about 7 ft (2 m).

• 'Lavinia' (1982) makes a short, bushy climber of about 8 ft (2.5 m) with strong satin-pink flowers. Generous quantities of elegant furled buds open into loose, well-scented flowers, and the show continues for a long time. This rose was named for the late Duchess of Norfolk.

• 'Lichtkonigen Lucia' (*aka* 'Light Queen Lucia', 1985), although often listed as a shrub, is much more likely to respond like a short climber in our conditions and, as such, it outperforms even the much-admired 'Golden Showers', which has long been the standard for a yellow climber. It blooms in clusters of clear sunshine-yellow flowers which do not fade and have a sweet fragrance. The foliage is dark and disease-free. A versatile, almost thornless grower which will clothe an arch, wrap a post or drape the side of the house, its height depends on the way it is trained—up to perhaps 10 ft (3 m).

• 'Madame Alfred Carrière' (1879) is an outstanding member of the Noisette family of roses, most of which are too tender to do well this far north. The exquisitely-scented white blooms open from pink pearl buds, singly or in softly drooping small clusters, filling the evening air with their fragrance. Never without flowers from June until frost, the plant has long, flexible canes which make it ideal for training over a trellis or up into the open branches of a tree where the flowers can cascade from above. Some feel the limp leaves give it a tired look and mildew can be a problem in late summer but the rose is strong enough

to shake it off without any apparent loss of vigour. At maturity it can reach a height of 15 ft (4.5 m), by which time it tends to be bare around the base, so surround it with tall bulbs or grow a small clematis through its lower canes.

• 'New Dawn' (1930) should, strictly speaking, be listed as *'The New Dawn'*, its registered name, but it is more often found under the two-word title in catalogues and books. This is the rose that has it all: beautiful flowers of pale shell-pink, excellent repeat bloom, distinct fragrance, vigour, and reasonable health despite a tendency towards mildew on the tips of the canes late in the season. Its flexible canes will wrap an arch or cover a spread of fence as effectively as any rose and they are well clothed in glossy green foliage which highlights the shapely flowers. It can easily grow to 15 ft (4.5 m) and will continue to bloom well into fall. This rose originated as a seedling from 'Dr. Van Fleet' and is identical to its parent except for its continuous bloom. Trivia buffs may be interested to know that 'New Dawn' was the first rose ever to be granted a patent.

• 'Penny Lane' (1992) is a relatively new miniature climber, meaning it will reach 7 ft (2 m) but the flowers and leaves will be diminutive. Reports from England where it was introduced have been glowing and that is usually a good recommendation for our climate too, but it has not been available here long enough to know for sure whether it will be a winner. (After all, 'Compassion', rated as England's favourite climbing rose, has never lived up to its reputation in our region.) Flowers are a pretty pale pink.

• 'Royal Sunset' (1960) is a strong-growing plant with shapely, large, Hybrid Tea-style blooms in rich apricot with a corresponding fruity scent. Copper highlights in the dark foliage enhance the impact of the

flowers. Strong, stiff growth to around 10 ft (3 m) means that it is best against a wall or solid fence where it can be fanned out over a large area. It blooms heavily in early summer and is never without flowers thereafter.

• 'Sombreuil' (1850) is the oldest rose in this category, and the only old climbing tea rose both hardy and healthy enough to recommend for our climate. Sweetly scented, creamy-white flowers with that ruffled old rose look spangle the lush green foliage in early summer and continue sporadically into fall, its perfume becoming more intense in this later blooming. This classic beauty needs a warm, sheltered location where it is protected from frost and cold wind. It will climb to about 10 ft (3 m).

• 'Warm Welcome' (1991), an absolute standout in several ways, is a miniature climber that will clothe itself from top to bottom with masses of shapely little tangerine blooms. Miniature refers to the size of the blooms rather than the eventual height which is likely to be around 7 ft (2 m). Foliage that is purple when young, bronze-tinted later, provides a fine contrast to the flowers, the combination appealing even to those who normally shy away from orange tones. If the spent blooms are left on at the end of the season, attractive scarlet hips will form. The stiff upright growth makes it ideal for growing on a pillar.

• 'Westerland' (1969) is often listed as a shrub but in west coast conditions it is easily persuaded to grow to 8 ft (2.5 m), making it suitable for arbours and fences. Dazzling golden and apricot blooms on sturdy canes appear in distinct flushes from late spring into fall against a backdrop of exceptionally healthy, large, dark leaves. The scent is strong and fruity. Cut out old canes every few years to encourage new growth and more flowers.

Ramblers

The characteristics that distinguish ramblers from climbers often overlap, and so some roses may find their way into either category. Those listed below have wiry, flexible stems that allow them to be wound through open fences, around pillars or through the branches of trees. With some encouragement in the first few years, they can also be trained up the sides and over the roofs of ugly buildings to turn them into swans for at least part of the year. Most ramblers have one glorious burst of bloom in July, followed by a display of hips in fall and winter. A few give some late flowers here and there, and a very occasional one will give a second satisfying flush of flowers in autumn. Almost all are well-scented and the best can envelop a garden in perfume. Although 15 to 20 ft (4.5 to 6 m) is the average mature height, some varieties are capable of more; if so, this is mentioned in the description. As the dates of introduction show, this is a class of roses that has had few new entries in the last century, a pity since their adaptability, healthiness and stunning display of bloom is not equalled by any other class of rose.

• 'Adelaide d'Orléans' (1826) is an excellent rose for twining through an open fence or a trellis and is high on my desert-island list of the roses I couldn't live without. Cascades of softest pink to white, semi-double flowers with golden stamens make it a breathtaking sight in bloom and the strong sweet fragrance is reminiscent of primroses. Its neat dark foliage with a purple tinge is evergreen in a mild winter, and leafs out quickly after a more severe one.

• 'Albéric Barbier' (1900) is another of the excellent ramblers raised by the French grower Barbier and the one he named for himself, which tells you how highly he rated it. It has clusters of butter-yellow buds that open into creamy-white rosettes, sharply framed by the glossy,

dark green foliage. A fruity fragrance and the ability to produce a few more flowers in early fall contribute to its appeal.

• 'Albertine' (1921) was also bred by the famed French hybridizer Barbier and is possibly the best known of his introductions. In full bloom it is covered with large, salmon-pink, dishevelled flowers opening from reddish buds. The perfume is rich and seductive. Strong plum-coloured canes are well armed with vicious thorns. Its moment of glory is from mid-June to mid-July but there are always a few later flowers once it is established.

• 'American Pillar' (1902) just smothers itself in bright pink flowers with a touch of white at the centre, making a show-stopping display for little or no effort on your part. Once established, it can be utterly neglected, being both vigorous and hardy. Its drawbacks are a lack of scent and a tendency to mildew where air circulation is poor.

• 'Bobbie James' (1961) is a giant of a plant, quite capable of enveloping a three-car garage or scaling the tallest tree. More reliable in our climate than the better-known 'Kiftsgate', it has similar huge trusses of simple, white flowers with a pervasive fragrance, and is sprinkled with small red hips in fall.

• 'City of York' (1945) is another big, white rambler, exceptionally healthy with a strong fragrance of oranges. The creamy white clusters of double flowers with lemon centres make a grand display, and are followed by sizeable hips that give the plant some later value in the garden.

• 'Constance Spry' (1961) is the rose that began the dynasty of David Austin's English roses. Although it blooms only once, and then for a month at most, the warm satin-pink, globular flowers are so fragrant and make such a spectacular display that it merits a place in any garden. Attractive grey-green leaves make a satisfying backdrop for later blooming plants when its own flowers are done. This is the rose often pictured in English gardening books blossoming romantically against a wall behind an elegant white bench. You can forget to water, deadhead or fertilize this rose and it will thrive in spite of you, making wide, arching growth to 10 ft (3 m) or more. It can also be grown as a large shrub but be sure to prune it like a climber as it flowers on the second-year growth.

• 'Félicité Perpétue' (1828) together with its sister rose, 'Adelaide d'Orléans', is among the small group of sempervirens ramblers still available today. Both live up to their "evergreen" description in a mild winter and are among the first to leaf out again if they *do* lose their leaves. This one begins its flowering season with clusters of lipstick-pink buds, opening into tiny rosettes of purest white. The effect of a half-in-bud, half-fully-open specimen is a beautiful sight and flowering continues over four to five weeks. It is a very healthy rose—hates to be sprayed, in fact—but not as fragrant as 'Adelaide'.

• 'Francis E. Lester' (1946) is like apple blossom when it is in flower, with masses of small pink and white flowers exuding a strong sweet perfume. Its strong arching canes are quite thorny enough to make a barricade and it needs no pruning unless it wanders further than you want. Red berries follow the flowers, sparkling like beads in late fall, turning a dull tomato shade by the end of the winter. You can cut them

off at your leisure to tidy the plant for spring, or let them shrivel and fall of their own accord, hidden under the cloak of new leaves that covers the canes in March. My chickens provide us with winter entertainmnt as they leap to grab at the little fruits hanging enticingly above their heads.

• 'François Juranville' (1906) is a very vigorous grower whose frothy, salmon-pink, quilled flowers have a fruity fragrance. Dark bronze-tinted foliage contrasts well with the blooms and the canes have few thorns which makes it a good rose for a pergola or arbour where people are likely to brush against it. Once mature, it will produce a few extra flowers as the season progresses.

• 'Ghislaine de Féligonde' (1916), an all-time favourite of mine, is not only one of the few really reliable repeat-blooming roses in this category but outstanding for its excellent health. The colour is unusual, too, being an attractive apricot and pale honey blend, darker in the bud and fading to cream when fully open. Individual flowers are small but well-shaped and come in neat, rather elongated clusters. The canes are almost thornless, which makes it useful for doorways or arches, and the foliage is fern-like and a glossy grass green. Although not tops for fragrance, it has enough to satisfy the nose. Sometimes listed as a shrub, it makes a short climber to 8 ft (2.5 m).

• 'Lykkefund' (1930) is a rose from Denmark whose name translates into English as 'Lucky Find.' Lucky it may be, but not easy to find in North America. However, it is available through specialty nurseries and rates a mention for several reasons. First, its fine, narrow leaves are exceptionally healthy; second, it has outstanding fragrance; and third, it is virtually thornless, which makes it a great choice for planting where people might brush against it as they walk by. Best of all,

it offers a mass of pale butter-yellow buds opening to semi-double cream flowers overlaid with a wash of peach, each petal with a central vein of yellow. Add sprays of vermilion hips in the fall and you have a rose for all seasons.

•'Phyllis Bide' (1923), a free-flowering rambler, always manages to have some blooms on it from the first generous flowering onwards. Delicate, cupped buds open into clusters of pastel flowers variously shaded in peach, buff and pale yellow with lots of dainty green foliage to act as backdrop. In our unpredictable weather, the flowers are inclined to become somewhat mottled with pink spots as they age but this is a minor fault among so many good points. There is some fragrance but it is not strong.

•'Rosa mulliganii' (1917), another of the giants, is a common sight in the famous gardens of England but not so well-known here. My two plants each cover effortlessly about 40 ft (12 m) of fence-line. When they bloom, their scent fills the garden. The foliage, small and glossy green, is almost obscured by the huge, loose sprays of small, single flowers in July and ages to a dusky amber and red in fall. Vivid little red hips sparkle through the frosts of winter. Give it lots of room so that no pruning is necessary—the thorns on this rose demand the utmost respect. Fortunately it is exceptionally healthy and thrives on total neglect.

•'Seagull' (1907), yet another great white giant, is included because it has slightly more petals to each flower, giving them a double daisy look. It flowers in a great foaming wave that is intensely fragrant. Dense grey-green foliage enhances the romantic effect. Wonderful for surrounding a seat in a secluded corner or training up beside a second-story bedroom window, it will cover a good 20 ft (6 m) in time.

• 'Veilchenblau' (1910) is included here for two good reasons: its unusual colour and nearly thornless stems. The trusses of semi-double flowers are violet with streaks of white and fade to a dusky twilight blue. Small, healthy, emerald-green leaves and a strong, green-apple fragrance add to its charms. This rose teams beautifully with any of the white-flowered varieties and will tolerate semi-shade which may slightly reduce the number of blooms but intensifies their colour. Its usual height is around 15 ft (5 m).

Early Summer Clematis

Large-flowered hybrid clematis are among the stars of the summer garden. Hung on a fence, they make brilliant backdrops for border perennials. Snaking amongst the branches of a shrub or small tree, they spangle it with the borrowed beauty of their flowers. They even pair well with other climbers, winding their leaf stems lovingly around the canes of climbing roses or fighting their way through grapevines to emerge at random intervals with a sudden burst of colour.

The planting instructions for **Spring Clematis** (page 20) apply to these as well, but pruning is a different matter. The Lanuginosa hybrids that bloom in late spring and continue through the summer months produce their early flowers on last year's growth and their later, slightly smaller flowers on the new young growth. Obviously, if you cut them back in winter, you will lose the early flowers but this is the only time to do so if you want to control their size or change the direction they have taken. If you have lots of space, you may choose to tip them back a little in early spring to a strong pair of buds, particularly if you want to encourage bushier growth, but otherwise you don't have to prune them at all and can enjoy their flowers all summer long.

CLEMATIS

Choosing among the many varieties is usually a matter of personal preference combined with what is available at your local garden centres. If your local botanical garden has a spring plant sale, this is a good place to find some of the rarer ones.

The following recommendations are grouped according to their mature height as it saves both anxiety and labour if you can avoid the need to prune.

Small: 6-8 ft (2-2.5 m)

• 'Lady Northcliffe' is a good choice for a container, seldom reaching 6 ft (2 m) in height. It has proportionately smaller flowers in lavender blue with paler stripes and white stamens.

• 'Violet Charm' grows a little taller, and has elegant purple flowers with long, pointed sepals.

• 'John Warren' has large flowers for its size, in two shades of raspberry.

Medium: 8-12 ft (2.5-3.6 m)

• 'The President' with deep purple flowers and red stamens is one of the most vigorous in this size range. Its bold colour and generous bloom over a very long period have made it one of the most popular clematis.

• 'General Sikorski' is a striking wedgwood blue with crinkly edges and lime green stamens.

• 'Silver Moon' not only tolerates considerable shade, but looks best where its mother-of-pearl flowers and golden stamens can glow from the shadows.

• 'W.E. Gladstone' has huge lilac flowers, more than a hand's span in width, with purple stamens.

• 'Elsa Späth' (also called 'Xerxes') blooms in shades of intense violet blue streaked with purple. The tepals (petal-like bracts) are rounder and lie flatter than on other varieties, giving the flower a denser look.

Large: 14 to 20 ft (4-6 m)

• 'Madame le Coultre', also known as 'Marie Boisselot', is my favourite of this group because the white flowers have such a starched linen appearance. I let it climb a branch of grapevine trailing down the north side of a trellis. The sharp green grape leaves provide a perfect background for the wide clematis blooms whose overlapping tepals curve back ever so slightly at the tips as if they are trying to swim upward.

• 'Henryi' is another vigorous white variety, capable of climbing to 20 feet (6 m). The flowers have a stiffer look than 'Madame le Coultre', as if they have been traced out of heavy paper. This texture makes them a good choice for flower arrangers as they last much longer in water than other varieties.

• 'Mrs. Cholmondeley' may have an idiosyncratic British name (pronounced 'Mrs. Chumley') but is one of the longest-flowering clematis of all. Mrs. C. will ornament the garden from May to September with her long, lavender-blue flowers tipped in a darker hue.

• 'Ramona' (also known as 'Hybrida Sieboldii') is another lavender-blue clematis, with slightly rippled flowers on a vigorous vine, capable of reaching 20 ft (6 m).

Late Summer Clematis

Clematis texensis

Small tubular flowers with tepals separating into widely spread ribbons of colour characterise the *texensis* group of clematis. Perhaps to compensate for their size, blooms are usually richly coloured in tones of crimson and lipstick pink. 'Gravetye Beauty' is the best known variety with vibrant scarlet flowers. 'Duchess of Albany' is striped in pale and strong pink, while 'Etoile Rose' is cerise with silver-grey edges.

These are well-mannered vines, climbing to around 8 ft (2.5 m) and more tolerant of drought than other clematis. They bear their delicate flowers from late summer through into late autumn, showing up well against a backdrop of evergreens or a contrasting wall, or rambling through tall border perennials strong enough to support their weight.

Having a naturally herbaceous habit, they will die to the ground of their own accord in winter. On the other hand, tidy gardeners may prefer to prune the old growth away at the same time as they are clearing out spent perennials at the end of fall. A winter mulch will encourage lots of this new growth in spring.

Clematis florida sieboldii

The florida group of clematis is not hardy this far north but this one is so dramatic that it is worth considering for summer containers. After flowering, it can be brought into a cool greenhouse or room, given a little water occasionally and set out again in May. The exotic flower—large white tepals surrounding a froth of

purple stamens and a tomato-coloured eye—draws attention wherever it is grown.

There is a superficial similarity to passionflower but, unlike that rampant scrambler, this delicate little vine will only fill a 3 ft (1 m) tripod. A tomato cage is just the right size and if you encourage it to spiral its way to the top, it will completely hide its support when it is in bloom.

Clematis integrifolia

Midsummer bells of rich indigo blue are the hallmark of this clematis. It lacks the twining stems of other members of the family but can be strung like Christmas lights through low-growing shrubs or encouraged to hang over a retaining wall. Use some caution when training it as the brittle stems snap easily if forced where they don't want to go. A modest little vine, it produces shoots only a few feet long but the dark flowers with their milk-white stamens are very appealing to those who value the little treasures of the garden. Blooming through the later part of the summer, it should be hard-pruned in winter.

Clematis x durandii

Another of the non-twining clematis, this one will extend its stems a few feet in various directions, threading its way over and through perennials and shrubs in its path. The flowers are larger and flare more widely than those of *C. integrifolia*, but they share the same vivid colour, and look superb among plants with chartreuse foliage or flowers such as lady's mantle *(Alchemilla mollis)*.

Clematis 'Jackmanii'

The best-known of all the clematis and a garden favourite for over 100 years, *Clematis* 'Jackmanii' has huge flowers of vibrant royal purple with green stamens. Given strong wires to support its bulk, it will spread enthusiastically over a good stretch of wall, fence or pergola filling a 15 by 15 ft (4.5 by 4.5 m) area or travelling in one direction to almost twice that. 'Jackmanii Superba' is a variation on the original that is generally considered an improvement and there is also a white form 'Jackmanii Alba'.

 Flowering has usually begun by the end of June and carries on all through July and September. Nearly all of the jackmanii hybrids bloom on new season's growth and should be pruned hard in winter right down to the bottom set of buds on each stem. If you leave them unpruned, they will still flower but only above the point from which the new growth has begun in spring. The light crimson-flowered 'Ernest Markham' is an exception but although it will produce flowers on the old wood, it gives a much better display if cut back like the rest of its tribe. It also is more dependent than most clematis on a sunny aspect.

Deep jewel tones dominate the colour range, although one of the most spectacular is sky-blue 'Perle d'Azur'. 'Gipsy Queen' is violet blue with matching stamens, 'Rouge Cardinal' a deep, glowing claret. 'Niobe' is the darkest of all—a blood red so deep it is almost black.

Although most of the jackmanii hybrids are as vigorous as their parent, there are a few that restrain themselves to little more than 6 ft (2 m). Among them are 'Madame Edouard André', which has raspberry flowers with cream stamens, 'Comtesse de Bouchaud', a prolific bloomer, covering itself in mauve-pink flowers, and 'Hagley Hybrid', whose baby pink flowers with milk-chocolate stamens colour best in some shade.

Clematis viticella

Though not scented like many of the species and smaller than the jackmanii hybrids, the flowers of *Clematis viticella*, or Virgin's Bower, not only compensate in both quantity and length of bloom, but are also resistant to the clematis wilt that often plagues other members of this family.

Flowering from mid-June to early October, they make good backdrops or companions for shrubs that bloom at the same time and are classic partners for roses. A friend of mine grows claret-coloured 'Madame Julia Correvon' on a pergola with a number of old pink ramblers, the clematis bursting into bloom as the roses fade.

Among others in shades of pink, 'Margot Koster' is rose-coloured, 'Södertälje', a free-flowering, vigorous variety, is rosy red, while 'Kermesina' is deep crimson. 'Abundance' is dusty rose.

There are several excellent purple varieties including the species *C. viticella* itself, deep velvety 'Etoile Violette' and eggplant-coloured 'Polish Spirit' which is one of the most vigorous of this group, reaching as much as 15 ft (5 m). 'Purpurea Plena Elegans' has rosy mauve-purple double flowers on long stems which last well in water.

'Alba Luxurians' is a beautiful white with green petal tips and almost black anthers, 'Venosa Violacea', another white, is veined in wine-purple. 'Huldine', one of the most beautiful but also most temperamental clematis and inclined to sulk if not planted in full sun, is pale mother-of pearl and best allowed to climb high enough that the mauve bar on the underside of the sepals can be admired from below.

Like the jackmanii group, the viticellas should be hard-pruned in late winter to encourage the maximum number of young shoots which will bear the

summer flowers. If necessary, this pruning can be done as soon as flowering is over. You might want to take this option if your clematis is sharing space with another climber whose moment of glory comes in fall or winter.

Passiflora caerulea (Passionflower)

Although there are nearly 500 species of Passiflora, very few of them can survive outdoors in the Pacific Northwest. The most reliable member of the family is *Passiflora caerulea*, the blue passion flower, which flourishes in cool climates, and in a warm and sheltered location will even remain evergreen. Flowering season depends on the microclimate surrounding the vine and may begin in late spring and continue well into fall but summer is the season of most prolific bloom.

Because it climbs by means of twining tendrils and needs the support of wires or a trellis, it is an easy vine to train in a given direction, and the prominent wheel spokes of green stamens and brown stigma surrounded by fringed purplish-blue flowers and a fan of cream bracts lend a touch of the tropics to northern gardens. There is a pure white form, 'Constance Elliott', worth searching out if you like a more muted effect. Like many white flowers, it compensates with a more noticeable fragrance.

Although quite hardy, the vine is best planted against a warm south or west-facing wall where it will cover a considerable area in the course of a year. In a south-facing West Vancouver garden, one vine I know of easily climbs above roof level by mid-summer, although it is hard pruned each February. Good drainage is essential to success, as the roots are prone to rot in wet soil. Plant it under the eaves of a house where its roots can remain dry all winter and give it a winter mulch to help protect them from frost. Because the root system is small for such a vigorous plant, *Passiflora caerulea* will also grow happily in a pot, but should be moved to a sheltered area for the winter.

Maintenance is easy as no pruning is required during the growing season, although you can cut out dead or renegade shoots during the summer if they offend you. In February, the main stems should be shortened or cut to ground level. Resist the temptation to cut the vine back at the end of fall as you will weaken its resistance to winter cold. However, even if winter does the job for you and cuts live growth to the ground, new shoots will appear in spring if the roots have been protected and, as the flowers bloom on new wood, you can still look forward to a good display the following summer. If the winter has been mild, cut the stems back in February, either close to ground level or, if space is not an issue, to any point that suggests itself. Feeding with a fertilizer high in potash will encourage a long and generous

display of flowers.

Passionflower is not always easy to find in garden centres but if you know a friend who has one, you may be able to beg one of the small plantlets that spring from around the base of a mature vine. Failing that, cuttings are easily rooted; select tip or end shoots, cut just below a leaf node and dip in rooting hormone before planting.

For those who like a challenge, *Passiflora incarnata*, with smaller but well-scented lilac and white flowers, is worth trying against a warm, south-facing wall where its roots can be kept dry during the winter.

Lathyrus odoratus (Sweet pea)

Cottage favourite for centuries, and grown throughout the world for its colourful, fragrant flowers, the sweet pea is on everyone's list of annuals for the midsummer garden. Climbing by means of coiling leaf tendrils to around 7 ft (2+ m), the vines bear masses of flowers like old-fashioned sunbonnets in a row down one side of erect stems. The blooms last well in water and cutting helps to extend the flowering season from June well into autumn by preventing the formation of seed pods.

Seed, whether you collected it yourself from last year's crop or bought it new, should be soaked in water for a couple of hours before planting. In our well-watered soil you can get away without this, but soaking does ensure better germination. The seeds are undaunted by cold weather and can be sown as early in spring as the ground is workable. To get a head start you can sow them in late autumn, omitting the pre-soak as frost will do the same job but if you live in a rural area, you will merely be providing a winter feast for field mice and voles. (Seed is poisonous to humans, however.)

Good planting requires a little preparation. Dig a nice big hole or trench and fill halfway with rich compost or manure mixed with a little lime. Cover with a thin layer of soil and plant the seeds about 1 in (2.5 cm) deep and a finger's width apart. As the seedlings grow, fill in the rest of the hole around the stems. Pinch back the shoots as they grow to encourage them to branch out. Sweet peas need slender supports to coil their leaf tendrils around, so provide wire, netting or a tepee of thin sticks for them to grip. With some encouragement they can be made to weave through an existing shrub but unless carefully trained they can end up as an untidy tangle.

The 20th-century obsession with size and colour at the expense of fragrance has affected sweet peas so that the older, smaller varieties are still those with the strongest scent. The species itself has exceptionally fragrant maroon and violet flowers, as does 'Matucana' while the lilac and fuchsia blooms of 'Painted Lady', oldest of the hybrids, have always been favourites for flower and scent.

Sweet peas are most commonly found in packets of mixed colours. The Spencer varieties are

the most popular, producing frilly-edged flowers, larger than the species though not quite as well scented.

Among individual varieties, 'Cream Southbourne', 'Royal Wedding' and 'White Supreme' are highly regarded whites; 'Anniversary' and 'Mrs. R. Bolton' are good pinks; blues include the bicolour 'North Shore' in dark and light blue, and lavender 'Leamington'; 'Sir Winston Churchill' is bright crimson, while 'Firecrest' is an unusual mixture of hot orange and red; 'Wiltshire Ripple' is a fascinating combination of white streaked with burgundy.

Lathyrus chloranthus

For something a little more unusual than the standard type of sweet pea, this one has lemon-lime green flowers, but little scent.

Lathyrus latifolius

Perennial sweet peas have small but still attractive flowers and no scent. The magenta and plum flowers of *Lathyrus latifolius* are so often seen running wild along roadsides in the Pacific Northwest that it is regarded as a weed. But in situations such as dry, sandy soil where other climbers would fail it has the merit of constant bloom and good coverage. The pure white 'Albus' will climb to 6 ft (1.8 m) or more. 'White Pearl' has even larger flowers and is exceptional trailing over a bank or retaining wall.

Cobaea scandens (Cup and Saucer Vine, Cathedral Bells)

Treated as an annual, this vine will scale heights up to 16 ft (5 m) in its short lifetime; in the mildest areas, where it will overwinter successfully, it can achieve twice that height in its second year. This vigorous growth makes it more suited to a man-made structure than a living host as its weight may eventually snap the branches of the average shrub.

Seeds can be started indoors in spring and planted out in late May, or sown directly into the ground after the last frost in a sunny location protected from wind. Notch each seed with a sharp knife and plant them on their sides, covering lightly with soil. Plants will spend the early part of summer hauling themselves skyward by leaf-tip tendrils that twine around thin wires or poles.

In August, the curious flowers will appear from pale green buds. Greenish-white at first and slowly suffusing with purple, these plump bells with their flaring, frilled edges sit on a disc of green calyx—the "saucer" of their common name. Long, curling, greenish-white stamens extend beyond the edges of the petals. As flowers continue to open, purple and white ones bloom side by side until the first hard frost shrivels the vines.

One of the interesting characteristics of the flowers is that in the early pale stage they exude an unpleasant smell which attracts flies and bats but once the colour changes to purple—fortunately within a day or two—the scent becomes sweet, drawing bees and hummingbirds.

If happy, plants may produce large seedpods of papery seeds which can be collected and sown the following year.

The variety 'Alba' has brighter green leaves and pure white flowers, slightly larger than the original. 'Key Lime' retains the chartreuse tints of its buds on the opening cream flowers.

Rhodochiton atrosanguineus (Purple Bellerine)

Delicate and subtle, this little annual climber from South America is a good choice for threading through shrubs and small trees which flower at a different time of the year. Stems and thread-like leaf stalks wrap around thin twigs or strings, making rapid growth to no more than 10 ft (3 m) and often much less. The flowers hang horizontally on fine threads like rows of tiny pink bells with oversized dark purple clappers. The effect is rather phallic until the central flower tube begins to flare at the tip. Eventually it drops off, leaving the little parasol of a calyx behind. Flowering continues through midsummer into fall until the plant is zapped by the first frost. The leaves are glossy green, heart-shaped and large compared to the size of the flowers.

In the wild *Rhodochiton* grows in sandy soil but in the garden responds to better conditions with more vigour. Seeds should be started indoors about 8 weeks before planting out and given a sunny position in the garden well after the danger of frost is past.

Tropaeolum majus (Nasturtium)

This well-known annual of childhood gardens is easy to grow, satisfying in bloom and edible too, both leaves and flowers adding colour and a peppery tang to salads. Nasturtium seedlings do not transfer well, so they are almost always available only as seed. Plant the fat brown capsules directly in the ground in May in the sunniest spot in the garden and the poorest, sandiest soil. The richer the soil or the more shade they get, the more foliage they will produce and consequently fewer flowers. Within two weeks of planting, seedlings will appear and grow rapidly,

RHODOCHITON ATROSANGUINEUS (PURPLE BELLERINE)

producing flowers about two months later and continuing on until frost withers them overnight. The leaf stems coil like tendrils to grip wires or similar thin supports and even before the flowers appear, lettuce-green leaves, like miniature lilypads, make a dense, attractive screen up to 8 ft (2.5 m) high.

Black aphids are the bane of nasturtiums and difficult to eradicate as the plants don't like to be sprayed with the usual deterrents. Even ladybugs, so enthusiastic about green aphids, do not seem to have developed a taste for the black ones. Blasting them off with a strong spray of water is satisfying, if not totally effective. Other than that, the plants require no care, except watering if the foliage begins to droop in dry weather.

Not all varieties are climbers so read the catalogue or packet description carefully before you buy. Of course, the circumstances don't always let you know in advance. One year I was given a lovely big bag of seeds by a friend who told me they were a pale yellow climbing variety. I duly planted them along a run of recently installed wire fencing, ultimately to be covered by a rambler rose, and as they sprouted I looked forward to a living wall of colour. Unfortunately, they never made it above ankle height and, although they flowered profusely, they went unnoticed behind a screen of larger plants.

Flower colours range from pale yellow through orange to dark red and certain varieties have contrasting spots at the base of the petals. Since most nasturtium seed sold these days seems to be the short varieties, descriptions of the

climbers aren't very inspiring. 'Tall Mixed' seems comprehensive enough, I guess, but it's hard to find packets of a single colour. 'Jewel of Africa' is one that occasionally appears on seed racks. It has deep red flowers and variegated leaves, veined like marble in green and cream.

Tropaeolum peregrinum (Canary Creeper)

Another annual variety, not so well-known, this nasturtium has deeply lobed, emerald leaves like fat little frog's feet and bright sulphur-yellow flowers that justify its common name. Seeds can be sown indoors four weeks before planting out, or directly into the garden once the soil begins to warm up. Given string or netting to climb, plants will grow swiftly to 8 ft (2.5 m) and prefer a richer soil than their more common cousin above. The flowers hang away from the foliage on narrow stems, their frilled top petals and trailing stamens giving them the look of tiny, brilliant jellyfish floating on air.

Cabbage moth caterpillars love this vine and I have lost vigorous plants thanks to their depredations, so keep a constant watch. If you don't mind spraying, Bt (Bacillus thuringiensis) is an organic control that does not harm the leaves.

This climber used to be sown annually around the Yukon governor's mansion in Dawson City and is now being planted there again by the local heritage society.

Tropaeolum speciosum (Flame Nasturtium)

The most sought-after member of the nasturtium family, this perennial vine produces its dazzling scarlet flowers from late summer until frost . They have the shape of the more common annual nasturtiums with a long spur behind the

forward-facing petals, which are squarish and spaced apart around the central throat. The rounded leaves are a strong apple green, contrasting well with the fiery flowers and the attractive blue berries that follow.

A temperamental vine, it can be difficult to establish but, given the moist, sheltered conditions that suit it, may then spread by stoloniferous roots beyond where you would like it to stray. Although it makes a good stand-alone specimen, it combines well with dark evergreens, sprawling its way over the outside of their foliage. In Vancouver's Park and Tilford Gardens, long trails decorate a dark yew hedge in this fashion, illustrating just how dramatic it can be when provided with the right position and the right companion.

Mina lobata (Spanish Flag)

A most unusual climber, this annual starts out with bronze leaves that gradually darken to a deep forest green. Looking rather like a bean but with three-lobed leaves, it twines rapidly to a height of about 10 ft (3 m), just right for a simple metal arch. In mid-July, short bronze stems held stiffly away from the foliage bear flowers in a row down one side, about 8 to a stem, like a string of pennants flying from a mast. Each individual bloom begins as a tiny vermilion cone and as it lengthens, it changes colour, through shades of orange and gold to pale custard yellow. A flowering stem carries all colours at once, the lowest and largest pale yellow, the topmost a tiny red bud, and the display continues well into fall.

MINA LOBATA (SPANISH FLAG)

Campsis radicans (Trumpet Creeper)

Like ivy, trumpet creeper anchors itself by means of aerial roots, adhering to any vertical surface it is provided with. This makes it a useful climber for walls or posts where the gardener doesn't want to go to the extra trouble of stringing wires or erecting a frame, although it will appreciate a little extra support until it gets established.

Full sun is essential to produce vigorous growth and a profusion of bloom, and your plant may die if exposed to too much cold or wind. In a sheltered position and with a winter mulch, however, it will eventually reach a height of over 20 ft (6 m) and may be left to its own devices or cut back for neatness' sake after the leaves have fallen. In the latter case, prune again not far above ground in February in order to encourage lots of new shoots, control the eventual size and keep the flowers down around eye level.

Sprays of trumpet-shaped, orange flowers appear in August, unique in their unusual combination of matte surface and hot colour. Together with the bright green multi-leaflet leaves, somewhat like those of wisteria, they give the vine a tropical jungle look making it an excellent companion to plants like palms and bananas for those who want to bring an exotic look to their garden.

'Crimson Trumpet' has slender, deep red flowers and deeper green leaves, while *C. flava* (sometimes sold as 'Yellow Trumpet') has soft yellow flowers and paler leaves.

Campsis grandiflora has larger blooms but is not hardy in any but the most temperate regions of the Pacific Northwest and even there requires constant sun to induce it to flower. It is also less inclined to develop aerial roots, becoming a lax shrub rather than a climber.

Campsis x *tagliabuana* 'Madame Galen', a hybrid between *C. radicans* and *C. grandiflora*, is the most readily available of all the trumpet creepers. More compact than its parents, it is more suitable for the average garden and the flowers, a rich salmon colour with darker veining, appeal to a wider audience.

Dicentra scandens (Climbing Bleeding Heart)

Bleeding heart is best known as a perennial border plant, but this is a most unusual climbing member of the species with beautiful foliage and drooping, yellow flowers like flocks of perching canaries. The fernlike leaves, somewhat similar to columbines, are a pale jade green, turning soft gold in fall and it is the tendrils at their tips as well as slender twining stems that enable the plant to climb. On a trellis or arbour it can be induced to reach 12 ft (3.6 m), but is often much shorter, as its habit is to spread as wide as it is high.

Plant the tuberous roots in moist but well-drained soil, preferably in a spot that gets morning sun but afternoon shade and provide a wire trellis or similar support for the stems. The heart-shaped flowers appear in late June and continue over the summer into early fall. Bullet-shaped, pale purple fruits follow.

'Athens Yellow' is relatively new variety and there is also a white form, 'Snowflakes,' which is tinged green at the flower tips.

Eccremocarpus scaber (Chilean Glory Flower)

A perennial in mild coastal regions, glory flower can be grown elsewhere as an annual provided seed is started indoors in spring. It will climb rapidly to about 10 ft (3 m), producing little tubular orange flowers, hanging several to a stem like strings of goldfish tied by the tails, their open mouths rimmed in pale apricot. Its long period of bloom, from July to late fall, makes it a useful companion to other climbers that bloom earlier in the year. Fernlike, five-leaflet leaves with clinging tendrils are evergreen where the plant survives the winter.

Seed is readily available and should be sown several to a pot, thinning later to the strongest seedling. Plant out in early June in a sunny sheltered position and watch it go. After flowering, vines produce interesting warty seedpods, which can be harvested and saved for planting or sharing the following spring. Self-seeded plants often spring up in the immediate vicinity.

'Tresco' is the most common variety, with flowers in vermilion red or pale cream. *Eccremocarpus f. aureus* is a rich yellow.

Fallopia baldschuanica (Fleece Vine, Silver Lace Vine, Mile-a-Minute Vine, Russian Vine)
(formerly *Polygonum baldschuanicum*)

Not one of the most eye-catching climbers, this vine's chief merit is its ability to clothe a surface more thoroughly and faster than just about any other plant. In sun or light shade it grows 12 ft (3.6 m) in a season, eventually covering a good 60 ft (20 m) and spreading an ocean wave of twining stems and pale green, oval leaves over any unsightly object, even one of considerable size like a garage. The sprays of tiny flowers appear in August, blooming all the way down short lateral

branchlets and casting a mist of pinkish white over the whole vine. The display continues well into fall. Vines are deciduous but the tangle of brown stems has no particular appeal in winter.

Plants are not fussy as to soil and will cope with drier conditions than many other climbers. The thick, intertwining growth makes pruning next to impossible, so choose a site where you can let it grow unrestricted, or cut it to the ground if it outstrips its allotted area and let it gallop back the following spring.

Fallopia aubertii (formerly *Polygonum aubertii)* is almost identical to *F. baldschuanicum* and, according to current thinking, is merely a variant form of the latter. Botanists that distinguish between the two suggest that *F. aubertii* has slightly smaller flowers without the flush of pink that characterises *F. baldschuanica*.

Ipomoea (Morning Glory)

Unlike their invasive cousins, these members of the morning glory family will rarely survive a Pacific Northwest winter, allowing us to make full use of their pretty flowers in summer without fear of their escaping our control. In fact, with their heart-shaped leaves spaced at short intervals along the dark grey stems in a loose, open pattern, they are among the best vines for providing a thick summer screen around areas that are not used in winter.

Although not essential, it helps germination if seeds are nicked with a sharp knife or soaked for several hours before planting. They can be started indoors in April or planted directly into soil once it warms up in late spring. Friable, fertile soil will

encourage vines to wind their way to 8 ft (2.5 m) but use a fertilizer low in nitrogen to prevent too much growth of foliage at the expense of flowers. Hot sun will produce a generous succession of the blooms shaped like the gramophone horns on ancient record players. Although each flower only lasts a day, more are always ready to open with the sunrise—hence their common name.

The usual form is *Ipomoea tricolor* 'Heavenly Blue', whose sky-blue flowers have a white throat, but there are a number of other colours, including pink and white 'Roman Candy' and 'Scarlet O'Hara', whose name is self-explanatory. *Ipomoea coccinea* is a species with deep crimson flowers and *I. imperialis* 'Chocolate' has large, flaring flowers in a curious shade of pale cappuccino. *Ipomoea purpurea* 'Star of Yalta', shorter than the others at 6 ft (1.8 m), has silky,

royal blue flowers shading to purple where the colour seeps down into the throat.

An ornamental form of the sweet potato, *Ipomoea batatas* 'Blackie' is unlikely to bloom or produce edible tubers in northern regions, but its merit lies in its stunning black stems and the lobed leaves of deep, bruised purple with an occasional streak of emerald green. There is also a lime-green form called 'Margarita', obviously named for the cocktail, whose shield-shaped leaves make dramatic companions for 'Blackie'. These two foliage plants are reluctant climbers, best trained to spill from containers.

All of the *Ipomoea* can be treated as tender perennials: overwintered indoors or in a greenhouse, and set outside again after all danger of frost has passed.

Dolichos lablab (Hyacinth Bean)

This vigorous, annual member of the bean family looks much like its vegetable cousins but its stems are deep purple and the large heart-shaped leaves, olive green with darker veins when young, gradually become suffused with purple too. The attractive cerise-purple flowers, similar to sweet peas, age through lilac to white on dark purple stems held up and away from the foliage. It is a toss-up whether to deadhead these as they wither in order to get more or to let them develop into the equally decorative seed pods. These giant, translucent, claret-coloured pea pods hang like fingers, up to 6 in (15 cm) long from the twining stems.

Given a sunny position the vines can reach up to 15 ft (4.5 m) or more in a season and are good for quick screening, forming a thick mass of leaves and stems on a base of wire netting, strong twine or bamboo poles. Direct sow seeds in May, or start them indoors three weeks earlier. Feed well once established, but avoid high-nitrogen fertiliser which will reduce the colour intensity.

'Ruby Moon' has flowers which are light and dark pink and pods the same colour as the species.

Although the beans are said to be edible, this vine is chiefly grown for its ornamental value. For good eating, see the next entry.

Phaseolus coccineus (Runner Bean)

Not just a pretty face, the runner bean has long been a staple of the edible garden. It can also serve a decorative function, particularly in the increasing popular "potager"—the vegetable plot that doubles as an ornamental garden. One of the best uses of runner beans is as a divider between two areas—screening the compost bins from the vegetable beds, for example.

With the support of poles, netting or a trellis, runner beans will climb to 8 ft (2.5 m), producing a large bean pod with a coarse, almost hairy surface and a rich flavour. The big, grass-green leaves and scarlet flowers make a crisp combination that continues all summer with regular picking of the pods. Pods quickly become tough and stringy, so for the best eating, pick them very young or shell them and treat like lima or broad beans.

Runner beans can be planted directly into a bed prepared with moist, rich soil in mid-May. Soak seeds overnight beforehand, putting 3 to 4 seeds in each hole if planting at the base of tepee poles, spacing them 4 in (10 cm) apart if planting in a row. Seedlings should be visible in about 10 to 15 days and grow quickly. Flowers need pollination by bees to set their pods. When the vines are spent, cut them off at ground level, but do not pull them out of the ground as the roots are good for fixing valuable nitrogen in the soil.

'Scarlet Emperor' has vibrant red flowers but the most sought-after ornamental variety is the beautiful 'Painted Lady' whose blooms are a patriotic Canadian mix of red and white.

Humulus japonicus 'Variegatus' (Variegated Hop)

An annual version of the perennial plant described in the Spring section, this is a rather coarse, rampant plant, which is prone to powdery mildew in its latter days. However, the crisp white and green marbled foliage serves the gardener well as a fast-growing, temporary screen or camouflage for an ugly fence while other options are explored. It will cover 10 ft (3 m) in its single season and contrasts equally well with dark foliage or bright flowers.

Best planted late, after all danger of frost has passed, and encouraged by rich soil and regular watering, its twining stems will quickly clothe themselves in large, maple-shaped leaves.

Thunbergia alata (Clock vine, Black-Eyed Susan)

Clock vine is a somewhat temperamental annual climber of modest proportions, requiring a sheltered sunny position to produce its small, bold flowers. Seeds germinate slowly, even with bottom heat, and seedlings are often puny and susceptible to temperature changes, so don't plant them out until the soil is warm and overnight temperatures are mild.

However, in favourable conditions you will then be rewarded with a continuous display of the bright flowers, looking like children's drawings with their round black centres and semicircular orange petals neatly arranged around the edge. They emerge on thin, flexible stems from the leaf axils, the leaves themselves being light green and shield-shaped, narrowing to a long point.

In their native South Africa, plants grow to 10 ft (3 m) but in our climate, they settle for much less, often no more than a couple of feet, which makes them good subjects for containers, whether twining around a small obelisk, or hanging

from a basket.

Although orange is the most common colour, pale yellow and white varieties are also available, and seed packets often contain a mix of all three.

Schisandra sphenanthera (Magnolia Vine)

An unusual climber with small, waxy, terracotta flowers in early June followed by long strings of equally bright fruits like currants, this is one for the plant collector. Although it needs the protection of a warm wall, it does not care for direct sunshine, especially where the soil may dry out. The twining stems, capable of reaching 12 ft (3.6 m) will also require wires to cling to as they make their way upward. However, it needs no pruning and our slightly acid soil suits it well. Flowers are unisexual and both male and female plants are needed to produce the fruits which are the most arresting feature.

Bougainvillea

Definitely not hardy here in the Pacific Northwest, but easily grown in a 4-gallon pot and overwintered in a bright, cool place, *Bougainvillea* is a familiar sight in tropical or sub-tropical regions. I well remember its vivid magenta flowers smothering the garage of my childhood home in Australia. In this very different climate it will make a bright 3 ft (1 m) accent for a deck or patio if given a sheltered position in full sun and a support such as a tomato cage to twine around.

It can be taken outside in May and should be brought in again when nights grow chill in October. Prune it at this time or in early spring, shortening stems back against the support, and keep it fairly dry while dormant. During the summer, water and fertilize frequently but avoid high-nitrogen fertilizers or you will get more leaves and fewer flowers.

The ivory flowers are actually quite insignificant but they are surrounded by large papery bracts that give the vine its impact. Magenta is the most common colour, but it is now possible to find apricot, scarlet or white varieties. Some, such as 'Raspberry Ice', also have variegated leaves in green and white.

For those with limited space or a sunny deck, it is the essence of summer, and a little different from the usual petunias and pelargoniums as well as being longer lived.

Gloriosa superba 'Rothschildiana' (Glory lily)

The flowers of the Glory lily must be among the most exotic of climbing plants with their shuttlecock of scarlet and gold petals held high above spokes of long yellow stamens. Although not hardy enough to survive outdoors during a northern winter, tubers can be stored in a dry place and replanted the following spring. Better yet, plant the vine in a pot which can be moved indoors in the fall.

Gloriosa is not actually a lily as the common name suggests but a member of the colchicum (Autumn Crocus) family, which means that all parts contain the toxic chemical colchicine and should be handled with care.

Vines climb like sweet peas by means of coiling leaf tendrils and will reach a height of about 3 ft (1 m) or even double that in favourable conditions. Plant dormant tubers indoors in early March and move outside to a sheltered position in full sun at the beginning of June. Keep well-fertilized and watered, and provide wire or string strong enough to support the brittle stems without movement. The spectacular flowers should emerge from the leaf axils during late July through August.

Gloriosa is definitely a plant for those who like an interesting challenge. If tubers are not available it may be grown from seed but plants raised this way may take two to four years before they flower.

VITIS (GRAPEVINE)

 Autumn

As the year lopes towards fall, many climbers that have begun their flowering in late summer extend the show past the equinox and as they fade, foliage takes over, turning from green to the bright or dusky tints of gold, russet, red and cinnamon brown.

Some climbers have been saving their most dramatic performance for this last act, surprising us with a burst of flowers or dazzling us with the colour of their leaves; others have given us a first act of flowers already, and are now returning in a different role.

Late-blooming clematis open delicate flowers, their subtleties all the more appreciated after the brimming luxuriance of summer. Exquisite berries hang like jewels among falling leaves and bare branches and seedheads sparkle in the first frosts of late October.

Aconitum episcopale (Climbing Monkshood)

Since discovering the elegant and sinister monkshoods and wolfbanes, I've introduced a number of them into the garden and am especially fond of the late-blooming ones for the glamour they add to the late summer and fall garden. *Aconitum episcopale* is a climbing cousin of the border perennials, bearing the same heavily fringed leaves and spikes of lavender-blue flowers as its more common relatives. The flowers are similar to delphiniums, at first glance, but a closer inspection reveals the source of both their common and botanical names; each bloom is shaped like the cowl of a monk's robe.

An enthusiastic climbing monkshood can twine to a height of 15 ft (4.5 m) by midsummer, although it is often considerably shorter. Flowers begin to bloom in late August and continue through into October.

Aconitum hemsleyanum (also known as *A. volubile)* is similar but has royal blue flowers and blooms earlier—in July and August. As the flowers are rather sparse, it is at its best grown through shrubs that have flowered in spring, giving them a borrowed beauty when their own has faded. Plants are content with sun or partial shade but they hate to dry out so make sure they get adequate watering during dry spells. Seeds will germinate easily but are often not as richly-coloured as the parent plants.

N.B. Every part of the vine is poisonous, so wear gloves when handling and plant where it is not likely to attract small children or pets.

Fall-blooming Clematis

An easy-care, disease-resistant group, the fall-blooming clematis can be pruned hard each winter or early spring and will bounce back as the soil warms in spring, scrambling along wires or through other shrubs with a great deal of enthusiasm, while posing no threat to downpipes, gutters or host plants in the way that many vigorous climbers do. Apart from the annual removal of the old growth, all they need is to be planted according to the instructions under **Spring Clematis** (p. 20) and encouraged in the right direction from time to time.

Clematis rehderiana

A highlight of any fall garden, this clematis makes wonderful cover for a 8 by 8 ft (2.5 by 2.5 m) wire fence or arbour and will climb to 20 ft (6 m) if height is what you want. Cut to the ground in late winter, it will make rapid growth through the first half of the year with the toothed, pointed leaves almost visibly searching out holds for their twining stems. At the end of summer, the small, palest-lemon bells with their rolled up edges appear in nodding clusters on stiff, chocolate-coloured stems and the

scent of primroses wafts through the air.

Flowers continue for a long time, often right into November, and even when the whole vine withers it makes a dark brown silhouette that is quite acceptable at a time when silhouettes and seedheads are contributing much of the interest in the garden.

Clematis rehderiana produces many new stems from ground level which makes it fairly bulky around the base, so allow some space in front of it for this spread. I planted a meadow rue rather too close and by midsummer it had been swallowed up by the clematis. Admittedly the rue was past its own best-before date by then and showed no signs of having suffered from the embrace when it bloomed the following spring. Questing stems also tend to reach toward any nearby shrub, which you may regard as a bonus through a spring-blooming rhododendron but a drawback if the object in question has an elegant shape of its own.

Clematis terniflora (Sweet Autumn Clematis)

Sometimes labelled as *Clematis paniculata* or *C. maximowicziana,* this is a vigorous vine bearing a myriad of small, white, four-pointed flowers from mid-August to November. The total effect is subtle rather than showy, like a lace tablecloth thrown over the foliage. As so often with tiny white flowers, they compensate with a strong, sweet fragrance. Clusters of triangular leaflets are more polished than most clematis foliage and contrast well with the flowers. At the end of the season, seedheads like tiny silver fright wigs replace the flowers, contributing their own small gleam to the garden when they catch the light.

One plant can easily scale a fence in its first year but if you want a reasonable screen, pinch back the growing tips to keep it bushy near the base. Pruning is optional but, if you choose not to, watch for self-sown seedlings in the

area the following year. Plants will thrive in shade or sun and are quite amenable to north-facing sites as long as some sunlight can reach their tops.

Clematis orientalis (Orange Peel Clematis)

Once you see the flowers, the common name of this rampant climber becomes obvious. Each small bell is composed of four thick, slightly dimpled, matte-yellow tepals surrounding a tuft of short stamens. Flowering continues from late July to October, accompanied towards the end of the season by large fluffy pinwheels made up of many pale green silken threads. Sage green, finely cut leaves add to its attractions.

Plants rapidly ascend to 10 or even 20 ft (3 or 6 m), maturing into a tangled web of stems which can smother a shrub or small tree. If you grow one through a living host, control this tendency by cutting it down to about a foot above ground in November, eventually making a thick, woody trunk from which new shoots will spring each year. On an artificial support pruning is optional.

This is one clematis that likes a sunny position to flower well but keep the roots cool by covering them with a slab of rock or a cement paver.

Clematis tangutica

Very similar to *C. orientalis* but with thinner tepals, greener leaves and longer threads on its seedheads, which look like tufts combed from the fleece of an angora goat.

'Radar Love' is a less vigorous variety with bright

yellow flowers, growing to around 8 ft (2.5 m) and flowering later than the parent. 'Gravetye' has butterscotch-yellow lanterns. 'Bill MacKenzie', a hybrid between *C. orientalis* and *C. tangutica,* has the longest season of bloom, from July to October. It also has larger flowers and will grow to 15 ft (4.5 m). *Clematis serratifolia,* another look-alike, has smaller flowers but more of them.

Solanum crispum (Potato Vine)

Anyone who has seen a potato flower will recognise this as a member of the same family when the pale blue flower with its little beak of yellow stamens at the centre begins to bloom. The vigorous, bushy vines, clad with matte, dark green leaves, will scramble over their supports spreading high and wide to 15 ft (4.5 m) or more. In July, the loose clusters of flowers begin to bloom, increasing to their most impressive display in September and often continuing into October.

The downy stems need training and tying in to a support such as a trellis to maintain a neat appearance but a well-maintained plant makes one of the finest early fall displays of any climber, especially if you prefer a subtle, dainty rather than showy effect. Pruning can be done in spring, cutting out excess stems at the base and shortening side shoots.

'Glasnevin', with rich purple flowers and apricot stamens, has a longer season of bloom than the species and is almost always the variety available in garden centres.

Solanum laxum 'Album' (False Jasmine)

(aka *Solanum jasminoides*)

Although the species has pale slate-blue flowers, the white form 'Album' is the one most commonly grown. Its similarity to jasmine may have some bearing on this, despite the fact that it does not share the latter's fragrance. Growing swiftly to a wide 21 ft (7 m), it is excellent for covering the sheltered side of a building. The shiny green of its foliage and young stems acts as a crisp backdrop for the clusters of snow-white, starry flowers with their prominent gold stamens. In a sunny position it will continue to produce generous quantities of flower for several months, beginning in late summer and reaching its peak in autumn.

Although more self-supporting than *S. crispum*, it is not as hardy; stems are often cut back by frost but usually shoot again from the roots in spring. In mild winters, vines can quickly outgrow their allotted space and may need fairly drastic pruning.

There are two rarer forms, one with white variegated leaves and one with gold variegation.

Tropaeolum tuberosum (Tuberous Nasturtium)

Its perennial habit is not the only feature that distinguishes this nasturtium from its annual relatives. Where the flowers of other nasturtiums flare widely, those of *T. tuberosum* are trumpet shaped, held high on slender, curving stems. Terracotta orange with golden throats, and set off by gorgeous glacier-green, scalloped foliage, they appeal even to those who do not normally care for orange in the garden. Coverage is thick enough to make this a good screening plant, especially for an area which is mainly used in summer.

Another advantages of this vine is its late blooming season—from mid-September to frost. Although it dies back to the ground in cold winters, the tuberous roots generally survive and may even produce offsets that can be dug up and distributed around the garden. Plant them in sunny, sheltered corners and free-draining soil for the best effect.

'Ken Aslet' is the most popular variety, having slightly larger flowers and a longer period of bloom than the species.

Ampelopsis brevipedunculata (Porcelainberry)

A vine that will zip to the top of an arbour or fence and then begin to festoon it with foliage, this relative of virginia creeper is one to be used with great caution. Already a weed in more southern regions, it is a potential invader here too—"demonic on large trees" is one comment I've heard—so grow it on a man-made structure such as a pergola or confine it to a pot.

It's the fall fruits that make this a desirable garden plant, following summer's insignificant, greenish flowers. Beginning as small pale green berries, they ripen like tiny bunches of grapes, changing through striking turquoise to purple, indigo, and finally black, with all colours present in a bunch at the same time. Concurrently, the foliage, also resembling grape leaves, turns from green to russet red.

Pinching out lower shoots will encourage porcelainberry to fill out a little around the base but it is not a good choice for screening, as it really wants to scale its support before spreading thickly. Given free rein, it will climb to 30 ft (10 m). Moist, fertile soil for the roots, and sun where it flowers will give the best berry production.

The variety 'Elegans' has leaves marbled in pink and white. It is less vigorous than the species and needs a hot summer to set its fruits.

Parthenocissus quinquefolia (Virgina Creeper)

A feature of the autumn landscape, the five-fingered, vibrant scarlet leaves of virginia creeper have a long association with the classic grey stone facades of churches and universities. The vines are self-clinging, using adhesive tendrils to hug tight against the walls which are their usual support.

A brown tracery of stems in winter, vines leaf out early, making a dense curtain of sharp green, often with trails of younger, smaller leaves falling loosely down over the more mature growth. They can achieve a formidable height and spread of 50 to 70 ft (15 to 20 m).

In fall, when the foliage takes on its startling colour, it draws attention away from the garden below, especially if grown on a west wall where the setting sun can bathe it in golden light. However, it is not fussy about aspect and can be grown on any suitable surface, even a north-facing one. Dark blue berries, while not conspicuous from a distance amongst the brilliant leaves, add another dimension to the pattern on closer examination, as well as attracting small birds.

Plants need deep, fertile soil in their early years but once well-established are undemanding to maintain. Like all the self-clinging vines, they often spend the first year or two developing a good root system before they begin to climb and may need to be pinned artificially to the surface until their adhesive pads develop.

Parthenocissus tricuspidata (Boston Ivy)

Boston ivy has three-lobed leaves turning blood-red and purple in fall. It provides the same formidable coverage as virginia creeper and many gardeners prefer it for its glossier leaves throughout the summer months, even though the fall display is not quite as vivid.

The most common variety, 'Veitchii', has young purple leaves becoming bronze-green in summer and reverting in fall to a deep eggplant purple seeping into crimson along the edges.

'Lowii' is smaller, to about 15 ft (4.5 m), with correspondingly smaller leaves of enamelled green turning deep purple in fall.

Parthenocissus henryana (Chinese Virginia Creeper)

The third member of this group is the one to choose for early season interest. Although it does not have quite the impact of its cousins in fall, with leaves more like embers than fiery flames, its young foliage is more intriguing, being flushed with pink and beautifully veined in silver. This coloration shows up best where the vine is growing in a partly shaded location. Less vigorous than others of its family, it will grow slowly to around 20 ft (6 m).

Vitis (Grapevine)

While there are countless varieties of grape available for fruit production, the best varieties for decorative purposes aren't among the best for either table or wine grapes. Wine production is far too big a subject for this book, but a few of the best selections for eating are recommended under the heading **Edible Climbers** (p. 148). The varieties listed below are chosen primarily for their value in the ornamental garden.

All grapevines appreciate a fertile, well-drained soil and careful training to display them to best advantage. For an overhead canopy, allow two or three stems to coil upwards, pinning them around their support or providing them with wire for their tendrils to grip. When they reach the top, pinch out the tips to encourage them

to branch. Every winter while the vine is dormant, prune lateral shoots back close to the main stem to keep a narrow profile on the vertical section, and follow suit with as much of the horizontal growth as you feel inclined. On no account leave the pruning until the sap begins to rise as cuts will then "bleed" for weeks, robbing the plant of vigour and possibly even killing the severed stem.

If you are espaliering a vine, choose one strong stem and cut out all others that shoot from ground level. When it reaches the level where you want the first horizontal, cut it about the width of a hand below this point, just above a set of strong buds. Three shoots should sprout from this point. Pin the strongest vertically and the other two at 45 degree angles on either side. After a year these side stems can be lowered to a horizontal position. (Forcing a stem onto the horizontal severely restricts its vigour, which is why these side shoots are allowed to grow up at an angle until they are well-established.) Follow the same procedure once the central stem has reached the next crossbar.

Vitis vinifera 'Purpurea'

From a decorative point of view, this beautiful foliage plant is a standout. Leaves open a downy sage green in spring, take on bronze and purple tints during the summer months and are at their most glorious in fall when they darken and become suffused with crimson, just as the small clusters of grapes are turning from plum to black.

Its brooding colour makes it a great backdrop for bright flowers, especially those with a touch of black or purple in their petals such as hot pink *Geranium psilostemon* or white *Acidanthera* with its central star of bitter chocolate.

Follow the planting and pruning procedures given above but avoid fertilizers high in nitrogen which will reduce the intensity of colour.

Vitis coignetiae (Crimson Glory Vine)

The giant of its family, this monster can climb unchecked to 60 ft (18 m) and is unsuitable for all but the strongest support. Grown into tall conifers its dense growth will rob the trees of moisture and chlorophyll. A massive pergola is a much better place for it, not to mention a chain link fence, or any ugly structure that could use a disguise. I used to pass a property where it sprawled over a long stretch of stone wall, its huge, heart-shaped leaves vivid every fall in shades of gold, copper, plum and crimson against the sombre grey background. The leaves are textured like lizard skin on top and fuzzy brown underneath and overlap to form a solid cloak. Clusters of small, dark purple grapes mingle with their hot colours in October.

To maintain a modicum of control, plant it in poor, unamended soil, or where its roots will be restricted—at the base of a foundation wall, for example. Hard pruning in February also helps. If you are willing to prune in summer as well, it can be used to cover a much smaller area than its own inclination would allow but even then it needs a minimum 10 ft (3 m) of room to grow.

Vitis 'Brant'

It is surprising that we do not see this beautiful grapevine of Canadian origin in more gardens, especially north of the border. Developed in Paris, Ontario in the 1860s by Charles Arnold, it is a hybrid between 'Black St. Peter's', a wine grape, and 'Clinton', an old table variety.

Not as vigorous as the others, it will nevertheless approach 20 ft (6 m) at maturity. Although the dark purple clusters of grapes are edible,

they are hardly a taste sensation and remain quite bitter in all but the hottest summers. However, the leaves are to my mind the most beautiful of all its family. Bright green when young, they develop crimson veins towards fall, the colour gradually spreading over the surface of the leaf while behind it the last vestiges of green are turning to gold. In a good year at the height of autumn, some leaves have all colours present at once. Colours are not so vivid if the summer has been cool and wet.

Pileostegia viburnoides

Another relative of the climbing hydrangea, this vine has the virtue of being evergreen. Moreover, it needs less encouragement to climb than the hydrangea does, sticking to its host like glue. The ivory blooms begin as tiny florets like cake decorations and open into fluffy white pompons. It flowers in October, later than most other perennial climbers, but its true assets are its glossy leaves, grass green in summer, darkening in winter, and the contrasting cinnamon bark.

Another forest-dweller, it is not entirely hardy, except in the warmest areas, and needs a site protected from wind and strong sunlight. Treat it like all of this

group, planting in moist, humus-rich soil in a north-facing position and protecting young growth from the depradations of slugs.

Celastrus scandens (American Bittersweet)

Yet another candidate for the fall garden, with unremarkable flowers followed by eye-catching berries, bittersweet is an untidy looking vine, too rampant for most gardens but it will grow in sites where other climbers fail. It is hardy, wind-resistant and tolerant of any soil that isn't too sodden.

For the first part of the year it is, at best, leafy background for other plants. At its moment of glory in late fall the toothed oval leaves turn crisp yellow and masses of orange seed capsules split open to reveal a golden satin lining with a single red berry at the centre like a bright drop of blood. The display continues into winter until the leaves have fallen and birds have made off with most of the berries. Only female plants carry the fruits but at least one male is necessary for their production.

Bittersweet is useful for disguising unattractive shrubs or outbuildings, or for growing among hedging evergreens to add a little extra pizzazz against their sombre foliage in fall, but keep a sharp eye out for seedlings that may sow themselves in its neighbourhood.

Celastrus orbiculatus (Oriental Bittersweet) is a similar but even more rampant plant with a reputation for being invasive and is not a responsible choice for home gardeners.

Actinidia deliciosa (Kiwi Vine)

(formerly *Actinidia chinensis*)

Before the New Zealanders adopted it and changed its name, the kiwi vine was better known as Chinese gooseberry. This monster is grown predominantly for its delicious fruits which hang like brown, furry Christmas ornaments from the stems in autumn. However, it also has quite beautiful, fragrant flowers, white on opening, soft ochre after pollination, that cover the vine in their thousands in late spring.

This is not a plant for small gardens—a specimen in the University of British Columbia Asian Garden is over 80 ft (25 m) high in a Douglas fir, and poses a considerable threat to the tree. If you have the space for a substantial pergola, by all means consider a kiwi vine but be prepared to do some regular pruning and training to keep it within bounds. Both male and female plants are needed to produce fruit and these should be planted 15 ft (4.5 m) apart, so you are looking at a large chunk of the average garden to accommodate them. Commercial growers figure on one male for every eight females. Home gardeners might be better with *Actinidia arguta* 'Issai' which is self-fertile although the fruits are much smaller than *A. deliciosa*, about the size of a large grape.

Train young plants up posts on a single stem, discouraging their tendency to wrap the post and securing them every couple of feet with a strong tie. Pinch out the tip when it reaches the top and train the resulting two shoots in opposite directions along the cross-bars. Fruit is produced on new growth each year so prune in late winter while the vine is still dormant, cutting side shoots to within two buds of last year's growth. Add a handful of bonemeal to the planting hole but do no more fertilizing in the first year. In following years, feed in early March and again in early June with a high-nitrogen fertilizer sprinkled around the roots but not too close to the trunk. Water the plants well, especially in dry periods but make sure that the soil is well-drained as kiwis are susceptible to root rot.

JASMINUM NUDIFLORUM (WINTER JASMINE)

 Winter

At a time when few flowers are open, we look to plants with evergreen foliage or attractive structure to keep our gardens interesting. These are the days when pleasure comes from such subtle effects as a sugaring of frost on the wrinkled red berries of rambling roses, the gleam of polished leaves in a ray of cold sunshine or the tracery of naked stems against a contrasting wall. The few flowers that do grace this season are all the more appreciated, especially as their modest blooms are often strongly scented.

Clematis cirrhosa balearica (Fern-Leaved Clematis)

One of a few clematis that are evergreen, this species also blooms much earlier than others, often in January, with small bells of drooping greenish-yellow sparsely spotted on the insides in sienna brown. A fan of the attractive foliage surrounds each flowering stem like the base of a candleholder.

Although young shoots are tender, it is quite happy in a north-facing site, provided that it is sheltered from cold winds and frost, and will climb eventually to a controllable 10 ft (3 m). Its chief value is that it blooms at a time when other flowers are rare but the leaves are pretty all year long with the bonus of turning a pleasant bronze in fall. In a region where there are few evergreen climbers, it is surprising that it is not more popular.

'Freckles' has flowers more heavily streaked and spotted with reddish-brown than the species, while 'Wisley Cream' is paler and unspotted.

Hedera (Ivy)

Ivy holds a special place among evergreen climbers. For one thing, almost everyone, gardener or not, knows what it looks like and how it grows. For another, it has such strong mythological connections, especially with Bacchus the god of wine and, accompanied by holly, with Christmas.

But ivy is a thug and a responsibility. Unless you are prepared to rigorously control its growth, you will regret introducing it into your garden where it will overwhelm and eventually destroy all in its way, even sturdy conifers. More disturbing still is the increasing evidence that it is escaping into the wild and seeding itself where it has no business to be.

One of the interesting but alarming characteristics of ivy is that it behaves

HEDERA HELIX 'PEDATA' (BIRD'S FOOT IVY)

differently at different stages of growth. In its juvenile stage, which is the most familiar, it has climbing stems which attach themselves to solid surfaces by means of aerial rootlets. If, however, it runs out of support, it will convert to the mature or arborescent form, when it changes from a vine to a shrub. It will cease to put out rootlets, develop a more branching habit and begin to produce flowers and fruit. The leaves usually change shape too, losing their attractive indentations and becoming more oval.

It is at this arborescent stage that ivy has the potential to become a menace through the indiscriminate distribution of its seeds into all too friendly native habitats. Responsible gardeners will keep their ivy vines trimmed so that they remain in the climbing form and have no opportunity to develop fruit.

Ivies have other means of getting out of hand, too. Used as ground cover, they will develop roots wherever leaf nodes touch the ground and their speed in covering ground can turn them from an asset to a liability in short order.

Nonetheless, these vines do have virtues not shared by many other climbers. Evergreen, they thrive in the deepest shade, but will also grow well, if more slowly, in full sun. Any soil will do provided that it is well-drained and not too dry (rarely a problem in our area). Plants grow faster in richer soil but, if you have chosen a variegated specimen, poorer soil will produce more and brighter contrast—a truism that applies to most plants with coloured leaves. Pests are not usually a problem and maintenance is minimal, although a good clipping over in early June encourages healthy growth as well as ensuring a well-balanced look, neither top-heavy nor bare around the ankles.

Ivy is also versatile. Most often used to clothe walls, where it does little harm provided your mortar is sound, it will hang down as readily as it scrambles up, will twist along a sturdy wire or chain to make a swag, cover a difficult site where

grass won't grow, or envelop a woven shape to create a topiary tree or animal. Intertwined with flowering climbers, such as roses or climbing nasturtiums, its dark green, glossy foliage makes a splendid backdrop for pale or brilliant blooms.

While ivy is a popular choice for draping tree trunks, it is an unwise one, as stems can quickly escape out of reach. Although it is not a parasite and will, in fact, insulate a tender tree against heat and frost, its weight may break branches, especially in locations exposed to strong winds. It is particularly dangerous if allowed to attain its mature arborescent form, not only for the environmental reasons mentioned above but also because the resulting shrubby growth can rob a tree of necessary chlorophyll, killing it by degrees. When this bulk becomes top-heavy, it threatens to collapse, bringing the already weakened tree down with it.

Nonetheless, assuming vigilance on the part of the gardener, ivy can turn a dull tree trunk into a thing of beauty. The variety of leaf shapes and sizes, along with the choice of plain green or variegated in all shades of yellow from palest cream to rich gold, is wide enough to suit all tastes. The most common varieties are from the *Hedera helix* family, the so-called English ivy and by far the largest group, and *Hedera colchica*, or Persian ivy, which comes as plain green 'Dentata', yellow-centred 'Sulphur Heart' or yellow-edged 'Dentata -variegata'.

Hedera nepaulensis, although on the tender side in our latitudes, will thrive in a sheltered location to the point of becoming a nuisance. Grown in a pot to curb its exuberance, a variety like 'Marbled Dragon,' with leaves having an almost three-dimensional pattern of bruised purple and dark green laced with silver, makes a year-long garden accent. *Hedera canariensis* is another slightly tender species, usually represented by the decorative, cream-edged 'Gloire de Marengo' (occasionally sold as 'Variegata'). *Hedera pastuchovii*, while not totally hardy, is a good selection for climbing a tree as it sits closer to the trunk than most and thus manages to avoid the "beer can holder" look that so alters the proportions of a graceful tree. Another

tightly hugging variety is *Hedera poetica*, which has the added attraction of orange berries.

Among the vast numbers of the English ivy *(Hedera helix)* group, the following are some of my favourites:

• 'Glacier'—small, five-lobed leaves, roughly triangular in shape, are a soft silver green edged in palest cream. The pattern varies from leaf to leaf, some predominantly green, an occasional one almost entirely bleached of colour. Young leaves are occasionally tinged with pink, especially in winter. 'Glacier' is a slow climber, good for a limited space. As a groundcover, its density makes for a weed-free carpet but it can get out of hand if not carefully maintained. This same density and the appealing colours make it a popular choice for topiary.

• 'Goldheart'—with a splash of sunshine yellow in the centre of each dark, glossy leaf, this is one the brightest ivies. The combination of crisp colour with sharply pointed leaves well-spaced along the stems makes for a dramatic wall covering. Plant it in a sunny position and avoid high-nitrogen fertilizers for best colour contrast.

• 'Ivalace'—a compact variety with deep emerald leaves so shiny they look to have been newly polished. Their stiffly curled edges and dense growth give the plant a nubbly look.

• 'Pedata'—a bird's foot ivy, so-called for the small, three-pointed leaves, the middle one much longer and sharper than the others. It looks particularly effective tracing a meandering stencil of green bird tracks over a wall.

• 'Parsley Crested'—a curly ivy! Each apple-green, fan-shaped leaf is deckle-edged, giving the plant an airy look quite different from the heavy patent-leather foliage of other ivies. It is a restrained plant and excellent for training on a small frame in a pot.

• 'Buttercup'—one of the best golden forms, with foliage starting out in a good strong yellow, although leaves develop greener tints as they age.

Euonymus fortunei (Wintercreeper)

The virtues of this evergreen *Euonymus* as a climber are often ignored in favour of its value as groundcover. But, presented with a vertical surface, it will develop aerial roots and make its way gradually upwards to a height of 10 ft (3 m) or more. Less rampant and certainly less invasive than ivy, it comes in plain green or several colourful variegated forms and will thrive in almost any conditions, including poor soil and shade. Furthermore, it has no apparent pests, and is not deterred by competition from tree roots.

It is, in fact, a versatile addition to the garden in any season but since it is eclipsed by flowering climbers at other times, winter is when it really becomes an asset.

'Emerald 'n' Gold' is my favourite of the group, being a rich dark green and lemon yellow. In winter, young shoots are flushed with pink to give the whole plant a tricolour effect which is very attractive. 'Silver Queen' has pale yellow young leaves, becoming green with broad white edges by midsummer and it too produces pink-tinged young growth in winter. 'Emerald Gaiety' has apple green leaves with bold white margins.

Elaeagnus glabra

A rare but interesting vine in a family of serviceable shrubs, this is an evergreen climber with dark grey stems sporting shiny mid-green leaves whose tips curl downward as if frozen in a morning stretch.

A scandent shrub rather than a true climber, it winches itself upwards by means of sharply angled lateral stems, like half-open paperclips, that hook over

crossbars or branches. At the same time, it continues to produce lots of low, bushy growth, a virtue not shared by many other climbers, making it dense enough to serve as a good privacy screen.

Vigorous, and perfectly hardy in our latitude, it expands the all too small range of evergreen climbers available to us, and will, I hope, become better known as our sources of unusual plants continue to grow.

Jasminum nudiflorum (Winter Jasmine)

Another non-climber that can be encouraged to act like one, winter jasmine is an undemanding plant, tolerant of poor soil and neglect. However, if not trained and tied in by hand, it will grow into an untidy clutter of stiff stems like green knitting needles thrown in a heap. Pinned against a support, it can be given a fairly reasonable shape and will cover an area about 4 ft (1+ m) high and wide.

The bright yellow flowers are among the most decorative and colourful of winter blooms, spangling the bare stems from November into February. Sadly they do not share the fragrance of other members of the family. Small, dark green leaves appear in spring and clothe the stems through the warmer months.

Prune in March, shortening young flowering stems and thinning some of the old wood.

Lonicera fragrantissima (Winter Honeysuckle)

More of a large untidy shrub than a climber, this honeysuckle doesn't twine like its summer-blooming relatives but it can be trained over a fence or tied to a wall. It would not really qualify for inclusion in this book except for the fact that it is evergreen in mild winters and its flowers bloom around the end of February or even earlier in a sheltered position. Insignificant though they are, just tiny cream trumpets behind the leaf axils, they have a powerful and sweet fragrance—the kind that makes people stop in their tracks and look around to see where it is coming from.

Pinned to a fence at the back of a border, or tucked into a neglected corner, it will thrive in shade or poor soil, survive drought and suffer brutal pruning if necessary. Cuttings root easily and stems that are allowed to lie on the ground will often develop roots of their own accord.

Its long thin stems provide a convenient framework for summer climbers like clematis to grip and, as its own shape is so nondescript, combining it with one of these can only enhance its value.

Lonicera x *purpusii* is another winter-blooming honeysuckle, much like *L. fragrantissima* and almost as scented.

COMMON NASTURTIUM (TROPAEOLUM MAJUS)

 Climbers for Special Purposes

There are always situations where season is not the most impor-
tant criterion in selecting a vine. Sometimes the surface to be
covered has its own limitations that must be taken into account.
It is pointless to settle on a twining vine for wall interest if you are not
willing to install wires or a lattice to support it, and unwise to choose a
self-clinging climber for a surface that needs regular maintenance.

Sometimes the space available dictates your choice. A rampant
climber like honeysuckle is too vigorous for a simple tripod or even an 8
ft arch, while an alpine clematis—ideal for those purposes—has no
hope of disguising an ugly shed or hiding the compost bins.

If you are renting the property, you may want fast-growing
annuals for a minimal investment of money. Conversely, you may have
a family property whose garden will, you hope, hold memories of you for
your grandchildren in the fragrant roses you planted or the wisteria that
will slowly make its way along the pergola. Long-lasting beauty and
scent are likely to be high on your list of attributes.

The following section is designed to make these choices easier.

Climbers for Walls

The easiest plants to grow on walls are ones that come equipped with their own methods of attachment, enabling them to do all the work themselves while you merely trim here and there to keep them out of window frames and eaves. Their disadvantage is that you cannot paint or repair damage to the wall without removing them, which often means cutting them to ground level. Even then, they usually leave shreds of their existence against the surface that have to be sanded or scraped off before any repairs can be done.

There is always a concern that these climbers will actually damage the wall, loosening mortar or prising boards apart but this is only well-founded if there are cracks or gaps that questing tendrils can probe. A more serious potential problem is that many dense creepers trap a certain amount of moisture against a wall, so it is safer not to use them on materials such as unprotected wood that may eventually rot.

Where these drawbacks don't exist, some beautiful effects are possible. Nothing softens harsh corners or mellows walls like a cloak of greenery and, if at some point it flowers or turns colour, so much the better.

For large surfaces, the Parthenocissus family has a long tradition of service. Choose virginia creeper *(P. virginiana)* or boston ivy *(P. tricuspidata)* on a sunny wall, *P. henryana* for a shady one. From spring to late fall they will make close-hugging curtains of bright leaves—green through the early months and dazzling fiery reds in autumn.

Climbing hydrangeas are also happy in shade and *Hydrangea petiolaris* will reward you with graceful panicles of white flowers in summer. Although it is deciduous, the scrollwork of stems with flaking cinnamon bark is attractive in

winter. *Pileostegia viburnoides* is worth searching for if you prefer an evergreen cover.

Ivy still reigns supreme among the evergreen wall-coverings, with the variegated types brightening a gloomy corner better than almost anything else. Among the plain green ones, those with shiny or unusual leaf shapes, like 'Ivalace' or 'Parsley Crested', can be just as attractive.

Euonymus fortunei needs initial encouragement to stick to a vertical surface but the variegated selections are even more attractive than ivy, including quite strong pinks in their winter foliage. Although readily available, they are usually marketed as groundcovers. Their value as climbers is vastly under-rated.

Since walls trap heat so well, they are excellent locations for some of the tender climbers that need warmth to thrive. Trumpet creeper *(Campsis radicans)* and its relatives will only be really happy in such a place.

Many other climbers can be grown against a wall if provided with some additional means of support such as wires or latticework. The more space you can leave between the wall and the framework the better for two reasons: firstly, climbers that don't cling of their own accord stay healthier with good air circulation all around; and secondly, almost all of them will suffer in the dry, often alkaline soil hard up against a wall. Making sure that the roots get enough moisture, as well as enough room to spread, means planting them at least a foot (30 cm) away from the base and more than that if there are wide eaves above.

One of the most effective solutions that I have seen to this problem was a wire grid in a wooden frame suspended from the eaves by hooks; hefty eyehooks screwed into the wooden soffits, sturdy cuphooks attached to the top of the frame. The wire itself was the heavy-gauge kind used in construction to provide strength within concrete slab foundations. Supporting either a late-blooming clematis that can be hard-pruned after flowering or any of the annual climbers, this type of frame can be taken down and stored over the winter months or temporarily laid flat while the wall is painted.

Relatively free-standing plants like climbing roses are also good choices for walls but they do need pinning here and there to hold them against the surface. Provide either metal hooks and eyes drilled into the wall, or horizontal wires strung about a foot (30 cm) apart up to the 4 ft (120 cm) level. Be sure to use wire strong enough to take the fully-clothed weight of the rose. Plant the rootball well out from under the eaves and train the canes in towards the wall as they grow. Choose a variety that is not overly susceptible to disease, as air circulation will be limited where the foliage is held close against the surface.

A similar system of horizontal wires can be used to espalier a grapevine on a wall. Cut the stem just below the lowest wire and wait for new shoots to emerge. Choose the strongest to continue upward and tie in two others one each side at 45 degree angles. When the centre stem reaches the second wire, sever it again just below that point and follow the same procedure with the resulting shoots. Once the angled shoots have made good growth, they can be tied in along the

horizontal wires. Thereafter, the vertical shoots arising along their length will need pruning back hard every year while the plant is dormant but the effect is well worth it if you like a highly geometric pattern.

Inexpensive fan trellises are among the most popular supports against a wall, but they are not suitable for clematis or other climbers equipped with tendrils as the width of the laths is hard for them to clasp. Nor are they strong enough to withstand the weight of a vigorous climber such as a honeysuckle. Twining annuals like Spanish flag *(Mina lobata)* or one of the morning glories *(Ipomoea)* are lightweight enough, as is a rose of modest size like one of the miniature climbers.

Climbers for Latticework

Wooden lattice is the most popular type of trellis for the garden. It is easy to paint in any colour that appeals to you, and looks attractive even when not adorned. Some of the commercial products are quite flimsy, however, so bear in mind the ultimate weight they will have to carry when you choose your climber. Plastic lattice is also available but usually only in a rather glaring white that rarely enhances the beauty of the climber it is supporting.

The best climbers for lattice are those that will twine or can be threaded through the spaces between the slats. Climbing or rambler roses, especially the ones with flexible canes, work well, but check the ultimate size of the rose to be sure it doesn't overwhelm your structure. A rose such as 'New Dawn', for example, is easy to thread through the spaces but impossible to restrain to a standard 8 ft (2.5 m) panel. 'Ghislaine de Féligonde', however, would do nicely.

Many of the annual climbers such as beans, cup and saucer vine (*Cobaea scandens*) and morning glories will thread willingly through lattice, and have the advantage that you can do any maintenance in winter after you have cut them down. On the other hand, if you want a permanent screen, ivy will attach itself to the slats and thread through the spaces to make a solid cover. 'Glacier' is not too rampant and its pale colours seem to suit this kind of treatment.

Climbers for Picket Fences

With their equal amounts of solid wood and open space, picket fences are perfect for the kinds of climbers that have strong stems of their own and need the fence more as a guide than a support.

Assuming that the pickets will need repainting from time to time, vines that can be pruned to ground level or die down of their own accord every winter are a wise choice. Golden hop *(Humulus lupulus* 'Aureus'), passionflower *(Passiflora caerulea)*, *Clematis rehderiana*, and potato vine *(Solanum crispum)* are all suitable candidates. *Clematis* x *durandii* would also serve the purpose provided you threaded it in and out of the slats by hand. Any of the smaller rambling roses can be threaded through in this way too, but then of course you have their permanent structure on the fence and maintenance would have to be done around the stems. A thornless variety would make this easier; 'Veilchenblau', for example, would contrast very effectively with white pickets. Avoid choosing a really rampant variety if you want your fence to be at all visible, let alone accessible for maintenance.

Climbers for Chain-link Fences

Make the statement that chain-link fencing is one of the blights on the modern landscape and you'll be hard-pressed to find someone who'll disagree with you. But, while unadorned chain-link is hardly a thing of beauty, it is the most versatile of supports for climbing plants. Sturdy, maintenance-free and just the right combination of thin wire and open space, it can be disguised with a wide a choice of beautiful vines, either alone or in inspired combinations of your own design.

Clematis with their coiling tendrils are naturals for it and you can mix early and late-blooming varieties to ring the changes in every season. Start with *Clematis armandii* to provide year-round cover and spring flowers, and mingle smaller, later-blooming kinds like *C. viticella* or *C. texensis* cultivars in amongst it. Or use fern-leaved clematis *(C. cirrhosa balearica)* for a more airy effect and add one of the large-flowered hybrids like 'Countess of Lovelace' which has two periods of bloom in early and late summer.

If the soil is moist and rich, try a flame nasturtium *(Tropaeolum speciosum)* over a base of ivy. Where the soil is poor, turn a couple of chocolate vines *(Akebia quinata)* loose along a stretch of chain-link and even if they lose their leaves in a harsh winter, they'll mask it with dense loops and coils of tan stems.

Annuals like canary creeper *(Tropaeolum peregrinum)*, morning glory *(Ipomoea)* or sweet peas *(Lathyrus odoratus)* will grow fast and cover thickly during the warmer months and they combine well with evergreen twiners like ivy or

wintercreeper *(Euonymus fortunei)*.

Golden hop *(Humulus lupulus* 'Aureus') will clothe it through most of the year and if you let a dark clematis like 'Etoile Violette' string itself through that sunshine-yellow foliage, you'd have a dazzling summer composition. Of course, you'd cut both back in their dormant season and have to suffer the bare fence for a few months. Winter jasmine might be just the answer to that, unobtrusive most of the year but a cheering mix of green stems and lemon flowers from Christmas Day to Valentine's.

Climbers for Obelisks, Tripods and Tepees

Climbers that twine or cling with tendrils are naturally suited to these structures and the range is wide. The big issue is to match the size of the vine to the size of the structure. Most of the latter are no taller than 8 ft (2.5 m), which rules out honeysuckles, kiwi vines and the more vigorous clematis species.

However, *Clematis macropetala* and *C. alpina* groups in spring, or the *C. viticella* and *C. texensis* varieties of late summer are very effective, especially if two are combined, one from each season, to give two different effects at different times of the year.

If the legs of the support are thick at the bottom, tendril-type climbers may be unable to encircle them. A few thin bamboo canes or stakes around the base will give them the encouragement they need to reach a point where the diameter is

smaller. Alternatively, strong twine wound in and out around the legs and spiralling upwards will soon be covered enough to be unnoticeable.

Sweet peas are particularly effective on tepees and tripods, as are members of the nasturtium family like canary creeper *(Tropaeolum peregrinum)*. Purple bellerine *(Rhodochiton sanguineus)* or *Gloriosa superba* 'Rothschildiana' are more unusual choices. All of these, being annual or at least winter-dormant plants, allow the supporting structure to be stored over the winter months, which will certainly prolong the life of wooden ones.

Climbers for Trees

Pick up any gardening book by any authority and you can read enthusiastic descriptions of climbers mingling with the canopy of trees. Yet I have seen so many trees whose beautiful shape has been lost in a tangle of vines that I have major reservations about this combination. Are chandeliers more beautiful draped with cobwebs? Not in this writer's opinion.

Personal taste aside, there are practical dangers to consider before overwhelming a tree with a rampant climber. A mature ivy, for example, can deprive tree leaves of moisture and sunshine, thus weakening the whole tree—perhaps even killing it in the long run. A grapevine or a wisteria, especially one that has reached the top of its host, can snap the trunk or at the very least break branches with its weight. Hemlocks in particular, with their brittle crowns, are a poor choice to support such a vine.

However, because so many gardeners are attracted to the sight of trees festooned with flowers, the least that I can do is recommend some well-mannered climbers that will not attempt to upstage their host.

Chief among these are the climbing hydrangeas, not only because they

tolerate shade so well but also because their aerial roots adhere tight against the trunk. They hold their flowers firmly on their own branches rather than inflicting their weight on the framework of the tree and their fine tracery of stems allows the bark of the tree to show through, especially in winter. *Schizophragma integrifolia* makes particularly nice patterns of brown on brown but needs a rough-barked tree to entice it to grip. *Pileostegia viburnoides*, on the other hand, will stick tightly against a tree trunk but its evergreen foliage will not give you the same opportunity to admire the winter subleties of bark on bark.

Rambling roses are also tolerable companions for large trees. They, too, tend to carry a certain amount of their own weight and their deciduous nature gives a tree a chance to recoup its strength. 'Madame Alfred Carrière' has a sparse habit of growth which keeps it unnoticeable inside a tree canopy until its trailing canes burst into flower. 'American Pillar' copes well with challenging conditions and its flowers make a bright contrast against dark greenery. If the rose is attacked by mildew in the dog days of summer, the symptoms will be less noticeable behind the tree's foliage. One of the most attractive combinations I have seen wrapped the flexible canes of 'Félicité Perpétue' like a garland around the trunk of a tall evergreen.

All roses hate competition for water and nutrients in the root zone. Excavate a good-sized hole and line the sides with some kind of barrier to prevent tree roots from encroaching. Alternatively, be prepared every couple of years to get in there with a spade and drive it deep into the soil in a circle about 2 ft (60 cm) out from the base of the rose to sever any tree roots that might be heading that way.

Since most members of the clematis family like the shade and moisture under trees, they are popular as companions for them. They need to be planted some distance from the trunk in order to give their roots a chance to compete and should receive the same protection as a rose in succeeding years. A long bamboo cane or similar support helps them ascend into the lowest branches and from then on they

will make their own way through the framework. Really rampant species like *Clematis montana* will let fall a cascade of starry, fragrant flowers in late spring but consider whether you want to obscure the shape of the tree for the eleven months when the clematis is not in bloom. For smaller trees, the large-flowering hybrids make good companions and are amenable to being pruned so that they don't obscure too much of the tree's own beauty when they themselves are not in flower. *Clematis armandii*, being evergreen, is only an option if you hate the tree but are keeping it because it screens you from your neighbour.

Ivy *(Hedera)* can be beautiful on a tree trunk but it is important to keep it trimmed to a level you can easily reach if you want your tree to be long-lived. As mentioned above, it can become at best a nuisance, at worst a destructive force if allowed to escape out of reach. Wisteria, kiwi vines *(Actinidia),* porcelainberry *(Ampelopsis)* and grapes *(Vitis)* all have the same threatening tendencies and are safest confined to manmade structures.

Climbers for Containers

A surprising number of climbers will tolerate confinement in a container and tender specimens demand it if they are to overwinter successfully. Where the container is going to be left outside all year round, it must be large enough that the soil will not freeze in the coldest part of the winter. The worst possible situation is the sunniest one, as extremes of warm soil throughout the day followed by overnight chilling are more than most plants can bear. At the very least, site your container where it will not get the brunt of winter sun or insulate the outside with a wrapping of several layers of newspaper, some straw or a sheet of poly foam. This doesn't look attractive but, if the container is small, you can place it inside a larger one and stuff the insulating material in the gap between the walls. Better still, move it to a cooler,

protected location in late fall.

Smaller containers or very tender plants should be brought inside—to a cool greenhouse if you have one or to any area where there is both natural light and a cool temperature. Keep plants fairly dry during this dormant period, watering only when the soil appears quite dry.

Plants in containers need a more porous soil so that it will both absorb water easily and drain quickly. Use a packaged soil mix specially formulated for the purpose or mix your own using equal quantities of topsoil, peat moss or other fibrous material, and vermiculite or perlite. Add a small amount of bonemeal and water the mix well with a weak solution of liquid fertilizer. If you want to avoid regular fertilizing throughout the growing season, stir in a handful of slow-release granules. These are great labour-savers but they only respond when the soil is moist and the temperature is above 15 C (60 F), so in a cold spring you will need to supplement with a liquid feed.

Make sure there is a good drainage hole, or holes, in the base of the container. It is common practice to add a layer of gravel or pebbles at the bottom but far from helping with drainage this often prevents it, water being held between the two mediums by surface tension. It is much better to cover the bottom of the container with a fine mesh or a few sheets of newsprint to stop soil being washed out and then fill entirely with your prepared mix. Some sand or fine gravel stirred over the surface will ensure that water spreads evenly.

During the growing season, do not let the container dry out. In hot weather this may mean watering every day. If you did not use a slow-release fertilizer, add a liquid one to your watering can once a week.

For the many clay and glazed pots that are not frost-proof, such as those from Mexico or southeast Asia, annuals are natural choices because they can be scrapped at the end of the year and the containers stored for the winter. I would

recommend this course of action for any pot not actually carrying a label advertising its frost-resistance.

Naturally, you must provide some kind of structure for the vine of your choice to climb. Glamorous supports like wrought iron obelisks or handsomely woven willow tepees are best combined with airy climbers that will allow something of the support to show through. For more blanketing plants, a simple tomato cage or a couple of bamboo canes will suffice.

Clock vine *(Thunbergia alata)* is a tidy little climber for a shallow pot, making a 3 ft (1 m) pyramid of bright colour. Sweet peas will reach higher but can be pinched back as they climb to thicken their curtain of colour and scent. They are excellent for mixing with other plants as they take up little ground space and their roots add nitrogen to the soil. Nasturtiums will fill in thickly, too, if pinched back and are also good for hanging baskets or window boxes. Purple bellerine *(Rhodochiton atrosanguineus)* is sparse enough to be strung around one of the more ornamental supports. A single gloriosa lily *(Gloriosa superba* 'Rothschildiana') in a small pot or three in a big one will provide a conversation piece in late summer, after which the tubers can be dried out and stored in a cool, frost-free environment until next year. Better yet, mix it with *Ipomoea* 'Blackie' and 'Margarita' for a stunning tropical effect.

Almost any perennial climber can be grown in a large enough container but some of the really rampant ones like honeysuckle are obviously impractical, unless you like the challenge and high maintenance of bonsai. Those below are all suitable for a container of reasonable size, which is one I define as being light enough for one person to move unaided.

Clematis alpina, macropetala and the early blooming large-flowered varieties are good subjects and *C. florida sieboldii* must be grown this way for its winter protection. Choose a large container in a heavy material—clay, stone or wood—to protect their roots from heat. Plastic pots or containers with thin walls are

not suitable. At least 12 in (30 cm) wide and 18 in (45 cm) deep is preferable for a permanent planting, although they can tolerate a smaller pot for a year or two. Make sure the container has adequate drainage, use a heavy, compost-enriched planting medium, not a peat-based one, and plant deeply as you would in the garden. A large container can hold up to three different varieties, allowing for interesting colour combinations across several months of bloom.

If you are using a plant support in a container, install this immediately after planting and tie existing stems to it or attach new ones as they emerge. A metal obelisk is an excellent support but any combination of thin wires or twigs will serve. As flowers fade, prune the stems to a strong pair of leaves and pinch back resulting growth to keep the plants compact.

Keep the soil in the container moist at all times and use a liquid fertilizer when you water, omitting it during flowering and resuming thereafter to encourage later bloom. Prune out dead stems in late February and cut others back close to the supports to maintain a pleasing shape.

Bougainvillea is a must for a pot, as you will have to overwinter it inside. It will cover a 3 ft (1 m) structure very effectively with coloured bracts that are bright and summery even on dull days. Put this tropical beauty in full sun and don't feed it too much nitrogen or you'll get more leaves than flowers.

Growing porcelainberry *(Ampelopsis brevipedunculata)* in a container allows you to curb its invasive tendencies and maintain it at a manageable size. As its star turn comes in fall with the brilliant turquoise and purple berries, it can be tucked behind summer blooms for the first part of the year and brought forward when its fruits begin to ripen.

Wintercreeper *(Euonymus fortunei)* cultivars make good year-round subjects for containers but will remain shrubby unless you provide a fairly solid

trellis to encourage them to climb. They will also spill downward out of a container and you can get some interesting effects with judicious pruning.

Speaking of pruning, trained and clipped English ivy *(Hedera helix)* can look wonderful either side of a doorway in matching pots. You can use a topiary frame in any of a number of geometric or fanciful shapes and, of course, they will stay fresh and green even in deep shade or the dead of winter. This is a high-maintenance project but rewarding for people with small gardens and restless hands.

Annual Climbers

The greatest advantage of annual climbers is also their greatest disadvantage: they are with you for a summer and that's the end of it. So they are not a good choice where you want a year-round screen from the neighbours or the street, or a vine you can plant and then enjoy for years without further intervention on your part.

They *are* excellent for new gardens, giving you a attractive summer display

while you plan ahead for a more permanent feature. They lend themselves well to container planting, especially on decks that become inhospitable to both plants and people in winter. And they combine well with more permanent plantings for extra colour or texture. Most of them yield seed in autumn, which can be stored away for sowing the following spring and if you didn't like the results of your previous design, you can plant them somewhere else with entirely different companions and see if you like it better. Of course, you can move perennials around in this way too but with much more effort on your part and sometimes a prolonged sulk on the plant's.

Annuals are primarily chosen for their colour contribution to the garden, but their method of climbing needs to be taken into account when considering the framework you have in mind. Most simply need a support slender enough to wrap tendrils around and strong enough to bear their weight. A few like Spanish flag *(Mina lobata)*, morning glory *(Ipomoea)* or Japanese hop *(Humulus japonica)* will twine around anything thinner than a drainpipe.

Sweet peas have the bonus of fragrance and come in a range of hues from white through all the pastels to red and navy blue. You can choose a single colour or buy them in prepackaged mixtures. Spanish flag offers a limited palette, all in the yellow to red colour range. Morning glories are usually blue and cup-and-saucer vine *(Cobaea scandens)* is purple but both have a white form (look for the word *alba* on the label). Clock vine *(Thunbergia alata)* is a bold orange and black but

can also be found in white and yellow.

Nasturtiums come in the familiar orange but *Tropaeolum peregrinum* is bright yellow. Runner beans *(Phaseolus coccineus)* are usually red but the variety 'Painted Lady' has red and white flowers on the same vine and, of course, you can eat the beans when the blooms have gone. Purple bellerine *(Rhodochiton atrosanguineus)* has one of the smallest and most unusual blooms in cerise and eggplant purple, while hyacinth bean *(Dolichos lablab)* has dark translucent pods following its magenta and white flowers.

For foliage interest there is Japanese hop *(Humulus japonica* 'Variegata') with its emerald and white-splashed leaves or sweet potato vines *(Ipomoea batatas)* 'Blackie' and 'Margarita'.

Evergreen Climbers

Ivy dominates the category of evergreen climbers, being adaptable to most surfaces and providing a thick screen at all times or an open one if you are willing to keep it continuously clipped. Its versatility allows it to be trained into columns, around windows, over fences, or even through other climbers but its invasive tendencies make it a high-maintenance choice.

Pileostegia viburnoides is not easy to obtain but makes an elegant looping vine around a sturdy support or across a broad surface. The foliage is fresh-looking year round and the lacy flowers are an autumn highlight.

Euonymus fortunei and its cultivars are decorative climbers in all seasons and will cover ground as well, which makes them suitable for retaining walls or other changes of level. Their green, cream and pink leaves vary in intensity with the seasons and cover densely enough to suppress weeds.

Clematis armandii is excellent for a dense screen as long as it has wires to

wrap its tendrils around. The long, overlapping leaves give a three-dimensional effect without being bulky, lying quite close against a vertical surface and incidentally providing great habitat for small birds. It also has the prettiest flowers of the evergreen climbers.

Akebia quinata isn't strictly evergreen but will retain most of its nicely scalloped leaves in all but the chilliest winters. However, in exposed locations it does suffer from wind burn, which makes the foliage lose its fresh look and sometimes turn an unhealthy dull green or bronze.

All Season Climbers

Not quite the same thing as evergreen ones, these are deciduous climbers that have interesting fall foliage or winter structure or berries that decorate the bare branches after flowering and before spring growth.

Rambling roses are unparalled for these purposes, having crisp unblemished foliage, a short season of perfumed splendour and vivid hips that sparkle on the bare branches in winter. Some ring the changes with every season, like *Rosa mulliganii* which has plum-coloured young leaves which turn to glossy, dark green, then are masked by the cumulus clouds of heavily scented flowers. Russet and gold foliage in autumn mingles with shiny scarlet berries that remain after the leaves drop to sparkle on the bare branches until mid-February. Those who have room to grow such a monster will enjoy its everchanging performance.

Not quite so rampant is 'Francis E. Lester', whose leaves have a bluish cast that tones beautifully with the pink and white, fragrant flowers. The leaves don't change colour before falling but the large, red berries have formed by then and last longest of all—until the rose leafs out again in spring.

'Lykkefund', which can almost support itself by the time its strong basal canes mature to wrist thickness, coats its reddish whiplike canes with sprays of little orange beads. It has particularly attractive young foliage of fresh apple green and never seems to suffer from disease.

Wisteria blooms are so sensuous that they overshadow the virtues of the vine in other seasons. But the fern-like leaves are pretty in spring green and become a pleasant though not vibrant chrome yellow in fall. After they drop, the winter shapes of the branches, spiralling up and along their supports, have a spare beauty of their own and long silvery seed pods dangle like windchimes against a pale January sky.

Climbing hydrangeas also have an attractive leafless shape, an abstract pattern of rough, peeling, caramel bark trimmed with thick fringes of aerial roots. The spent flowerheads are as airy and lacy in warm winter brown as they were in their pristine white of summer.

Social Climbers

Just joking!

Although, on second thought, this is a good way to describe beautiful, perfumed roses like 'Ghislaine de Féligonde', 'Lykkefund' or 'Veilchenblau' whose smooth, thornless stems won't catch at your silk blouse or tear the toupee from your head.

Anti-Social Climbers

It's not generally a subject discussed in gardening publications but there are situations where the anti-social properties of a vine can be most desirable. What better way to burglar-proof your property than with a 24-hour armed guard masquerading as an innocent, decorative plant?

The backyard fence too easy to climb over or the deck accessed by glass doors with flimsy locks—these are places where a pretty but dangerous plant can put its dual properties to good use. A thorny rose is the ideal anti-social climber for such a strategy, bestowing flowers and perfume on you while drawing blood from your enemies. A big rambler like 'Seagull' or 'Francis E. Lester' will deter the most intrepid intruder, especially if you plant a couple of them along a fence, while even a modest climber like 'Royal Sunset' or 'Dublin Bay' can make a deck post or drainpipe inhospitable.

The majority of the evergreen climbers are not armed but wintercreeper *(Euonymus fortunei)* is a decorative exception. It has sharp little needles behind

the leaves, not exactly lethal, but quite enough to make it uncomfortable at close quarters.

Anti-social in a different way, all of the climbing monkshoods (*Aconitum hemsleyanum*, *A. episcopale*) are poisonous—stems, leaves, flowers, roots, seeds—so use gloves when handling them, and plant them out of the path of small children and pets.

Tough Climbers

The group of plants that will survive neglect or cope with conditions such as poor, rocky soil or atmospheric pollution inevitably includes potential invaders, so some vigilance is required in their cultivation.

Bittersweet (*Celastrus scandens*) is a case in point. Hardy and indestructible, it will easily spread by self-sown seedlings if you have both male and female varieties or the self-fertile clone. And this is exactly what you will have because otherwise it won't bear its decorative seed capsules at all and they are a large part of its attraction. The good news is that seedlings resent disturbance so if you are handy with a hoe and attack at the right time, you can foil its urge to conquer the world.

Ivy (*Hedera*) has a well-deserved reputation for tolerance. Shade, poor soil and air pollution are all just minor annoyances and probably serve to keep its vigour in check. Just as well, considering its ability to get out of hand. All of the wintercreepers *(Euonymus fortunei)* are equally tolerant.

Hydrangea anomala petiolaris prefers shade and it doesn't mind air pollution either, but it does like a fertile, well-drained soil and shelter from wind. On the other hand, hot, dry, infertile soil is perfect for climbing nasturtiums

(Tropaeolum majus and *T. peregrinum).*

Rambler roses need some care while they become established but after a couple of years of regular watering and a little fertilizer they will take care of themselves and can withstand considerable drought. Air pollution actually keeps them healthy; in industrial English towns reductions in factory emissions during the last century have resulted in more evidence of disease on rose foliage.

Small Climbers

If the support for a climber is modest, for example an 8 ft (2.5 m) arch or fan trellis, it is important to choose a plant that will not overwhelm its host. Although it is sometimes possible by dint of constant and severe pruning to force a large vine to remain small, it is often at the expense of graceful form, not to mention reduced flowering. Besides, a vigorous grower like a wisteria has all the potential to destroy a support more flimsy than its own mature size.

Some of the annual climbers are ideal in this situation, particularly sweet peas *(Lathyrus odoratus)* which rarely manage more than head-height. If you pinch out the growing tips regularly, it will not only restrict their height but encourage them to produce more flowers.

The morning glories *(Ipomoea)* and Spanish Flag *(Mina lobata),* which is a close relation, won't usually grow beyond 6 ft (2 m), and clock vine *(Thunbergia alata)* is another annual that won't grow out of reach. It can even be

restrained to no more than 3 ft (1 m) by wrapping it horizontally around a support.

Among perennial climbers, some of the clematis family are easily accommodated on small structures, including the spring-blooming *alpina* and *macropetala* types, as well as the late-summer *texensis* varieties. A few of the large-flowered hybrids, notably 'John Warren', 'Violet Charm' and 'Lady Northcliffe' are also quite restrained, growing to no more than 8 ft (2.5 m) and easily held to about 6 ft (2 m).

'Lavinia' and 'Ghislaine de Féligonde' are two roses that will not extend beyond 8 ft (2.5 m) and the same applies to any of the miniature climbing roses.

For a wall or an open fence, winter jasmine *(Jasminum nudiflorum)* can be made to cover a wide area about 4 ft (1+ m) high. Its dark green, angular stems need pinning to their support, but give twelve months of decoration and the golden flowers in midwinter are a cheering sight.

Huge Climbers

Not everyone has room for a monster of a vine in their garden and for them this category may be regarded as a list of what *not* to choose. However, for those wanting to cover the side of a house or drape the full extent of a fence or perhaps smother the outline of an ugly but useful shed, there is a wealth of plants to choose from.

The *Parthenocissus* family, which includes Virginia creeper and Boston ivy,

is excellent for covering walls, growing fast and requiring little maintenance other than clipping around windows and eaves. Ivy *(Hedera)* does this job well too but, as mentioned in the detailed description, it will need to be monitored to ensure it doesn't develop seedheads when it runs out of room.

Climbing hydrangea *(Hydrangea anomala petiolaris)* will also cover a lot of space eventually but will not cling as tightly to the wall. It is a good choice for a shady site, and can be encouraged over a free-standing trellis if you want to be able to get at the wall for painting. It can also be trained while it grows to give either dense or spare coverage of a surface.

Though it will never win the most-decorative crown, mile-a-minute vine *(Fallopia baldschuanica)* is the best there is if you want almost instant coverage of a low building or long fence. No care is needed, other than to chop at the tangle once in a while to groom it a little. *Clematis montana* has more beautiful and fragrant flowers but takes longer to reach full size, besides needing regular fertilizing and watering.

Wisteria is too inclined to prise drainpipes, siding and roof tiles off a house to be planted against it but is unparalleled for draping over a pergola. Big rambler roses like 'Albertine' and 'Seagull' are excellent for pergolas too. They need some tying in as their long canes extend, which can be a bloody affair, but their response to being laid horizontally over the top is to throw out masses of flowering lateral shoots. They are also excellent on fences with openings they can be wound through.

Kiwi vine *(Actinidia deliciosa)* is too rampant for almost any location and

a high-maintenance plant as well, needing pruning at least twice every year, but the more decorative multi-coloured *Actinidia kolomikta* is much better-behaved and the show lasts longer, although you don't get any fruit for the table. Grapevines *(Vitis)* benefit from pruning too but if you don't get around to it, the ornamental varieties will simply get bigger. Crimson glory vine *(Vitis coignetiae)* will cover a tremendous amount of fence or pergola if left alone.

Where the soil is dry and coverage in winter is not important, passionflower *(Passiflora caerulea)* is useful and still unusual, shooting from ground as far as 15 ft (4-5 m) in the growing season. In a really long, hot summer it may even produce some edible fruits before dying back in the fall.

Fragrant Climbers

One of the best things about climbing plants is how many of them fall into this category. With careful selection, you can have a perfumed garden almost year-round and as most of these vines will cover a substantial area, it is easy to surround yourself with a curtain of fragrance as well as colour.

In spring, both *Clematis armandii* and *Clematis montana* will cascade with pink or white vanilla-scented blooms. A little later, the pendant lavender-blue flowers of wisteria will cast their perfume on the air.

Summer brings jasmine, honeysuckle and sweet peas, but some members in each of these families can be disppointingly short of scent so check the individual entries to be sure of getting suitable specimens.

Among the roses, 'Francis E. Lester', my favourite rambler of the moment, has a particularly lovely fragrance, while *Rosa mulliganii*'s masses of little flowers enrich the air around them for a considerable distance. 'Veilchenblau' has a soft green-apple fragrance and the lovely 'City of York' smells of orange blossom. Repeat-

blooming roses are more likely to have sacrificed scent for a longer flowering period but 'Royal Sunset' has an attractive, fruity perfume and the tender tea rose 'Sombreuil' really does smell remarkably like a good darjeeling or earl grey.

In fall, sweet autumn clematis *(Clematis terniflora)* is heavy with almond-scented flowers and *Clematis rehderiana* offers a more nuanced, bittersweet primrose fragrance.

A month after the solstice, winter honeysuckle *(Lonicera fragrantissima* or *L. purpusii)* will begin to open its tiny ivory flowers, wafting intriguing lemon scents on the chilly breeze.

Spectacular Climbers

Sometimes what is needed is a really dramatic effect, created either by a vivid colour or by a large and unusual flower.

Passionflower *(Passiflora caerulea)* is excellent for this, with its vigorous growth and profuse blooms. The curious flowers are not strongly coloured but their unusual shape and the contrast of white, apple green and saturated lavender blue makes them a show stopper. Passionflower vines are still unusual enough in this region to draw attention purely because they are so exotic and unfamiliar and this is also true of gloriosa lily *(Gloriosa superba* 'Rothschildiana'*)*, which makes a small but brilliant addition to a late summer composition.

The large-flowered clematis have a deserved reputation for adding knockout drama to the garden. 'Nelly Moser' with its candy-striped flowers demands to be noticed and 'Jackmanii's combination of dinner-plate size and intense violet-purple colour is just as effective. The large white varieties like 'Madame Le Coultre' stand out like neon among colourful perennials and on a much smaller scale, the white and purple combination of *Clematis florida sieboldii* draws all eyes when it begins

to bloom. The *viticella* group of clematis don't have the advantage of size to make their impact, but compensate by the vast number of flowers they produce. When 'Etoile Violette' blooms in my garden, it always hogs the limelight, no matter how hard its nearby companions try to claim their share of attention.

Even the clematis with tiny flowers generally manage to make such a show that it is no wonder they are regarded as the reigning monarchs of the climbing plants. If they combine this display with fragrance, the impact is all the more impressive.

Bold colour is the greatest asset of nasturtiums. The oranges and yellows of *Tropaeolum majus* are so well-known because their ability to clothe a wall with colour has kept them high on the list of popular annuals. *T. peregrinum* has slightly smaller flowers but their orchid-like appearance and bright yellow colour add considerably to their impact. Similarly, the rich scarlet of *T. speciosum*, especially against a contrasting background, outshines even the brassiest autumn perennials.

Vines that have rich autumn tints also catch the eye. All of the *Parthenocissus* have the ability to paint a wall with scarlet as their leaves switch from summer to autumn dress. Grapevines like 'Brant' are large enough and vivid enough to be noticeable from a distance as well as offering an intricate pattern of reds, greens and golds upon closer inspection. Crimson glory vine *(Vitis coignetiae)* makes a vast curtain of red and purple magnificent enough to satisfy the most jaded eye.

Edible Climbers

The practical gardener looks for more in a vine than beauty. For people with limited space or a plot in a community garden, or those productive people who prefer the satisfaction of growing their own food over the decadent pleasures of lolling among the flowerbeds, there are several vines that can offer an annual harvest.

Runner beans *(Phaseolus coccineus)* are the best known edible vines, covering quickly and thickly the supports they are given. With increased interest in the French-style potager—the ornamental vegetable garden—these vines really come into their own, fulfilling both decorative and edible functions. Grown on tepees or tripods, they have the virtue of taking up little space and hung on a surrounding fence, they make effective and useful screens. Scarlet flowers, or the red and white contrast of 'Painted Lady', make an attractive display before the pods form and the more you pick the more you encourage further flowers and beans. For use as green beans, the pods are best picked while young and thin and this must be done almost daily as they mature so rapidly into tough, stringy jaw exercisers. Don't despair if they grow too big—they can always be shelled and cooked as broad beans.

Hyacinth bean *(Dolichos lablab)* has shiny, maroon pods that would certainly look decorative on a plate but, although they are edible, no one seems to recommend them as a taste sensation.

Sweet peas don't produce good pods for eating but the peas sold for vegetable production will also produce flowers, though much less colourful than the ornamental varieties. Usually they are a pleasant but unremarkable white, although some varieties are flushed with pink or purple.

Kiwi vines *(Actinidia deliciosa)* are cultivated commercially for their fruit

but are only suitable for a large garden as they require so much space and a sturdy frame to boot. Unless you are able to get the hermaphrodite *Actinidia arguta* 'Issai', you will need both a male and a female plant to get fruit and these should be planted 15 ft (4.5 m) apart, which gives you some idea of how much room they require! Vines are extremely prolific, with more than enough fruit for family and friends, but they do need training onto an arbour or framework of strong posts and wires, as well as regular pruning. Fruit rarely ripens on the vine this far north but it will ripen after picking as long as it has developed a certain level of sugar. Leave it on the vine as long as possible but try to harvest before frost. Stored at temperatures just around freezing, it will keep for up to three months.

Most of the ornamental grapevines don't produce very tasty fruit. 'Brant' is supposed to but, although the bunches ripen to a luscious dark purple, I have always found the taste quite mouth-puckering. Since it was bred for prairie conditions, it probably requires a hotter, dryer summer than the coastal northwest climate provides and may develop juicier grapes in inland, fruit-producing areas such as the Okanagan Valley. *Vitis coignetiae* produces bitter little berry-like grapes, popular with birds rather than humans, while *Vitis vinifera* 'Purpurea' is a wine grape and not a particularly good one at that.

If good taste is paramount and you are content with decorative green foliage, a table variety such as 'Interlaken' which produces the ever-popular green seedless grapes is a better choice than a grapevine with more ornamental properties. 'Himrod' is another green seedless type but less hardy and more temperamental than 'Interlaken'. 'Campbell Early' produces a concord style of grape and is a better choice in northern climates than the sun-loving 'Concord' itself. 'Candice' is an early-fruiting, seedless, pink table grape suitable for most areas of the Pacific Northwest. 'New York Muscat', although not prolific, produces an excellent black dessert grape.

Several vines also produce edible flowers although these are more often used as garnish rather than served as a fruit or vegetable. Nasturtiums *(Tropaeolum majus)* have a peppery flavour that adds a tang to salads and the flowers contribute an attractive colour contrast. All parts of the plant are edible, including the seedpods which can be pickled and used as a substitute for capers.

Honeysuckle *(Lonicera)* flowers have a sweet flavour, as anyone who has picked a flower and sucked the nectar through the stem end can recall to memory just by closing their eyes. They make pretty additions to salads or desserts.

Rose petals can be dropped into champagne, added to sorbets or scattered over cakes, but cut off the bitter white area at the base of each petal before using. If you also paint the underside of washed rose leaves with chocolate, peeling them off when it has set, you will have chocolate foliage to go with the petals. Rose hips are edible too, but those produced by climbing roses are generally too small to be practical for making jam or jelly. Only the skin and pith is used in these preparations as the seeds can have unpleasant short-term consequences in the digestive tract.

Spillers

Plants that prefer to go down rather than grow up are ideal for tumbling over a retaining wall or flowing from a hanging basket. The ultimate size needs to be taken into account when selecting a suitable vine, as too thin a veil looks miserable while too vigorous a blanket can overwhelm a small container.

In a modest trough or basket, clock vine *(Thunbergia alata)* will dangle a gaily coloured curtain of flowers to about 3 ft (1 m) although it can be clipped to less if necessary. *Bougainvillea* has rather woody stems but can also be encouraged to descend over the sides of a pot, and morning glories *(Ipomoea)* are naturals for

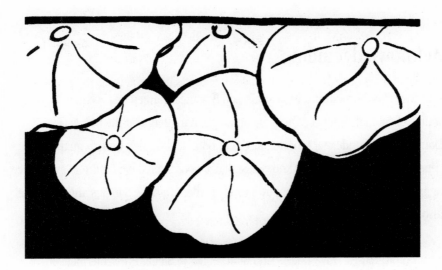

trailing.

In a larger container, such as a big window box, white potato vine *(Solanum laxum* 'Album') will make a curtain of evergreen foliage and add crisp linen-white flowers in summer. Ivy is another evergreen candidate for this kind of treatment, and is easier to control in such circumstances than planted out in the garden. It looks particularly striking against a white wall.

On a sunny bank, common nasturtiums *(Tropaeolum majus)* are excellent for creating a lush mediterranean summer effect, and they aren't fussy about soil or water. I have a vivid memory of seeing them spilling thickly down a stone wall, flaunting their hot oranges and golds against the severe grey background.

There is also a Japanese groundcover rose, not mentioned elsewhere in this book, that will send long ropes of foliage and flower down a 6 ft (2 m) wall. 'Nozomi' has tiny pearl-pink flowers embroidered all the way down its slender stems. It blooms in June and again, more frugally, a couple of months later.

Acknowledgements

Carolyn Jones, horticulturalist at VanDusen Botanical Garden has been an ongoing source of valuable information to me on all plant matters over the last decade. Douglas Justice and Peter Wharton at U.B.C. Botanical Garden were more than generous with their time and knowledge. Janet Wood shared her firsthand experience of growing many climbers in her own lovely garden. Darlene Sanders and Jan Tuytel also contributed their expertise.

Sandra Hargreaves, Guy Chadsey and Colin Fuller at Steller Press alternately encouraged and bullied me into writing this book, as did my husband Michael Kluckner who also made it a thing of beauty with his illustrations and design.

Index of Plants

Also from Steller Press

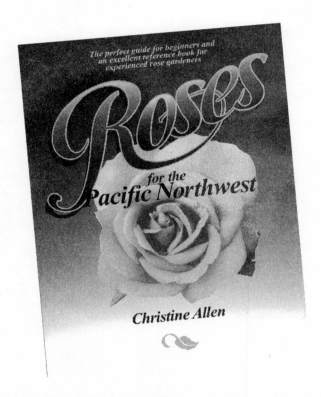

Sooner or later every gardener comes around to roses. Of all the flowers in all the gardens of the world, roses seem to exercise the greatest powers of attraction while at the same time generating the greatest apprehension and fear of failure. Let Christine Allen guide you as you choose your roses and care for your rose garden.

STELLER
press limited